Dan M. Lee

ilex

Creative Photography
The Professional Edge

C Contents

1 Landscapes, Cities & Skies

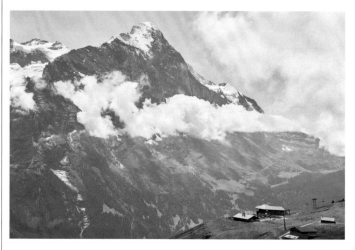

6 Introduction

10 Essential Filters for Waterfalls
14 Filters for Sunrise & Sunset
16 Why Polarize?
18 Composing Sunrise & Sunset
20 Sunset from Another Angle
22 Silhouettes
24 The Crystal Ball
26 HDR Landscape
28 Sunburst without a Filter
30 Celestial
32 Star Trails
34 Shooting Through a Telescope
36 How to Capture Lightning
38 Using Tilt-Shift
40 Tiny Planets
42 Fresh Street Photography
44 Low Angles

2 People & Lighting

48 Lens Whacking
50 Side Lights
52 It's All in the Eyes
54 Make a Rembrandt Anywhere
56 Daylight Flash
58 Personal Project
60 Macro Portraits
62 Stock Up on People
64 Follow the Flow
66 Single Strobe Work
68 Light Painting
72 Light without Focus
74 Projector Light
76 Altered Bokeh
78 Digital Multiple Exposure
80 Light without Spill, Wherever You Are
82 Get a Green Screen
84 Lip Match
86 Vortograph

3 Interiors & Real Estate

90 Creating a Narrative
92 Flat Facades
94 How to Be a Vampire
96 Shoot Flambient
98 Outside In
100 Pop-Pop
102 360° Shots

4

Air & Sea

110 Aerial Photography
114 High Altitude
116 Best Cameras for Aerial Photography
118 Drone Photography
122 Drone Panoramics
124 Drone Video
126 Going Underwater
130 Underwater Flash
132 In & Out
134 Upside Down & In the Drink

5

Lifestyle & Concept

138 Food Photography
142 Fine-Art Still Life
144 High-Speed Capture
148 Motion Blurs
150 Sell Your Gear
152 It's a Macro World After All

6 Business Building

158 Keep Current
160 Online Promotion
162 Where the People Go
164 Test Yourself, Test Your Gear
166 Moving Pictures
168 The Cinemagraph

E Endmatter

172 Index
175 Picture Credits

Introduction

At first glance, this might seem like an unconventional book, but there's a reason for that. This book is not arranged to take you from the beginning of a journey to the end; it's not a training manual or a school coursebook. There are plenty of those and that's a good thing, but this is something else. This is a book for people who have already mastered the skills – who know their aperture from their shutter – but who find themselves asking, 'What more can I do?'

In this day and age that's a very important question. People are constantly exposed to a barrage of new, different, interesting and challenging imagery by the hour and by the minute. Where once it was possible to learn your craft and master it, now you need to have a wider perspective, always looking for other things you'd not thought of trying – things you might have thought belonged to other areas.

The walls between photographic genres are crumbling; technology has made it possible for us all to experiment a little, and every once in a while we absolutely need to.

This book, then, is about saying that none of us can afford to stop looking at the possibilities the world offers. You don't need to read it from front to back, or cover to cover in one sitting. Instead we hope that you find it a source for inspiration. Look at the photos you wish you'd taken and find out why you have not; make some time to try new techniques. Even if you see something you don't like, that response can spur you on to a new way of thinking.

Ultimately the goal of this book is to challenge your ideas about being a photographer, about what you can and cannot do (and with what device). The aim is to open your mind to new approaches and open your client list to keep you ahead in a difficult marketplace.

1

Landscapes,
Cities & Skies

Essential Filters for Waterfalls

Many pros don't reach for their filters enough, but in-camera ISO adjustment has its limits.

A neutral density, or ND, filter works to limit the amount of light into your camera without you needing to adjust the exposure. Surprisingly, quite a lot of professionals get by without them in their bags, but these filters do offer possibilities for shooting water that nothing else can replicate. If you're going on a landscape shoot, ND filters are indispensable.

Photographing water is a situation in which setting a specific shutter speed makes all the difference to the water's appearance, while setting a specific aperture controls the look of your shot. Since that shutter speed is likely to be long to achieve the blurring effect seen in the examples, and there are limits to what a narrow aperture can do to mitigate the extra light that will fall on the sensor in that time, the solution is to use an ND filter. If you think the solution is to reduce your ISO (light sensitivity) you're also out of luck; image sensors typically cannot be set to below ISO 100.

A filter is a glass fitted to the front of the camera either by a screw mount or a holder. The LEE Filter system is an example of a filter holder which allows the photographer to slip in the glass of their choosing; it is more flexible when it comes to graduated filters, as the filter can be moved around the composition.

ND filters are measured by how many stops of light they block, so they're easy to understand in terms of the rest of photography. A 2-stop ND filter would have the effect of blocking the same amount of light as closing the aperture on your lens from $f/11$ to $f/22$, but with no effect on the depth of field. You can source a 2- or 3-stop ND filter from any good camera shop.

Another filter that's very handy is a circular polarizer. Like an ND filter, it blocks light, but it's very useful for removing glare from rocks and wet surfaces that may overexpose parts of the image and be distracting. You can twist the circular polarizer to adjust the amount of glare reduction. Keep a close eye on your viewfinder to observe the effect. Try not to overdo it, as

that can affect the image in undesired ways, especially if the filter is a lower-end one. Try to avoid any filters that seem unbelievably cheap, because the price will likely be reflected in the quality. And be sure to purchase a circular, not linear, polarizer if you intend to use autofocus at all, as linear polarizers confuse cameras' autofocus systems.

Combining these filters can give you complete control over how the image will come out, long before you visit Capture One or Lightroom. So experiment as much as you can to understand how these work together and view the images in camera or tether to a computer as you shoot to view them (although that might not be feasible if you are close to water).

Hopefully, you already have found a location with a waterfall (or a beach with a good tide), so set up your tripod and take some sample shots, leaving the shutter open for a few seconds and checking the results each time. There is a good level of trial and error involved in this kind of shooting, but a great place to start is to keep your ISO low (100 or 200) and use a small f-stop such as $f/8$ or $f/11$. Make sure you use a shutter release so you don't get any camera shake.

If you find the scene is too dark, but the smoothness of the water is good, then you can nudge your ISO up a little or set a slightly longer shutter speed and work backwards. You can approach this in a few ways. I recommend setting your camera to Aperture Priority and a low ISO, using the aperture size to control the shutter speed.

If that is difficult due to the type of lens or camera you have or there is very limited light, then use Manual exposure mode and start at ISO 200 and $f/11$ with a shutter speed of around 1/3 of a second before you add the filters. After a few test shots, add the filters and start shooting. Make sure you turn off any Long Exposure Noise Reduction or Image Stabilization features when using a tripod and a long exposure.

Notes

Circular polarizing filters are convenient to attach to most lenses, but you'll need one for each different sized lens screw.

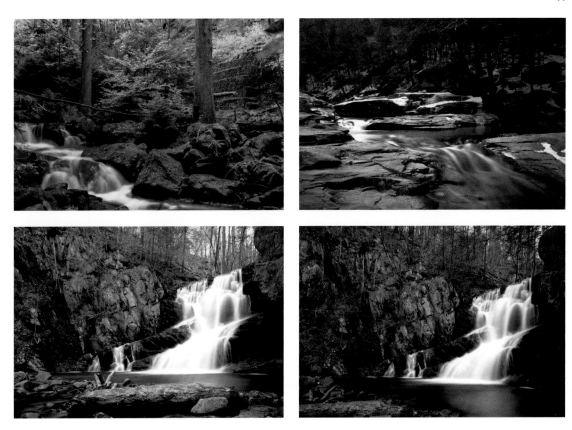

Normal Shutter Speed	With 6-9-Stop ND	
1/2000 second	½	second
1/1000	1	second
1/500	2	seconds
1/250	4	seconds
1/250	8	seconds
1/60	15	seconds
1/30	30	seconds
1/15	1	minute
1/8	2	minutes
¼	4	minutes
½	8	minutes

Top, Left & Right: You can really see how the circular polarizer makes a difference. The upper images have got great composition, but the water is looking a little murky – both images were taken with a UV filter but no circular polarizer.

Bottom, Left & Right: The image taken with the circular polarizer and UV filter on the left is clearly better and much more interesting, with deeper and richer colours, even though the composition is roughly the same.

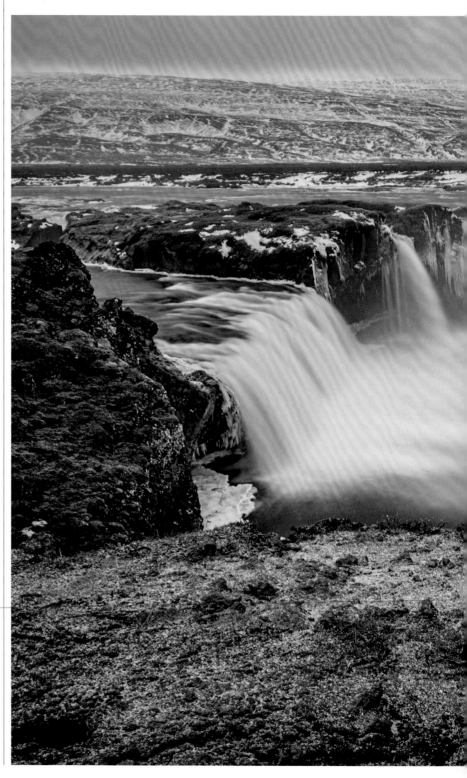

Right: Here is an example of a challenging scene. This and the examples on the previous page are different environments with different types of waterfalls to shoot. A wide-angle lens allowed me to capture the large waterfall and include the context, both foreground and sky, to show the grand scale of the falls.

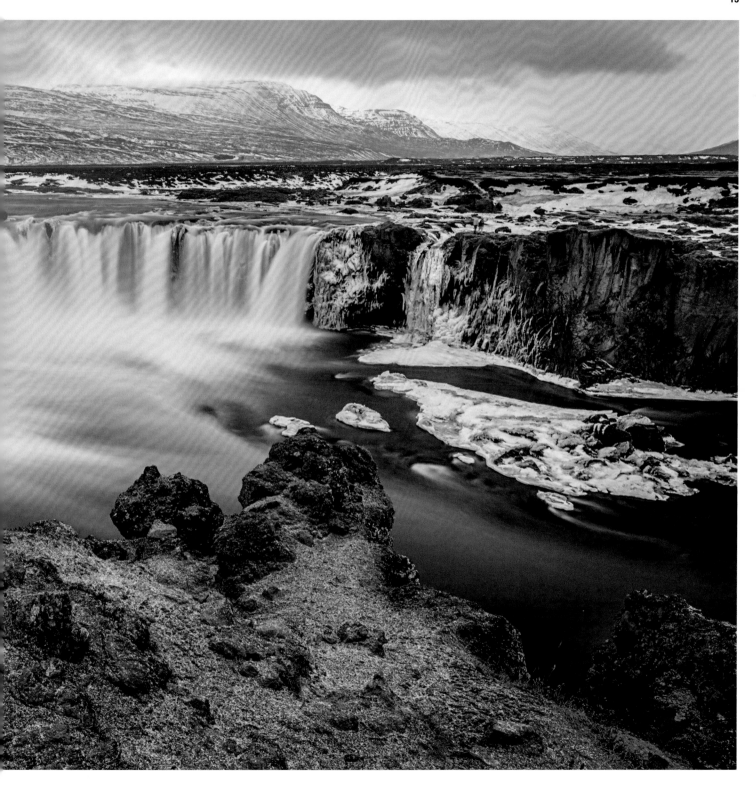

Filters for Sunrise & Sunset

Some classic effects still can't be duplicated in post-production.

Stunning sunsets are a favourite of mine to capture and with some handy filter glass, you can take some of the guesswork out of post-production and get what you need in-camera.

Graduated filters are key when it comes to shooting sunrises and sunsets. You can get them with a soft or hard edge, which refers to the transition between clear and filtered glass. Hard-edged filters have a clear line, while soft-edged filters transition gradually. (See the graphics opposite.)

Again, you can buy filters that sit in a filter system holder (highly recommended) or screw-type filters that thread onto the front of the lens. Great lenses for sunrise and sunset shoots are anything super-wide, for example, 10–30mm. Do your research before settling on a filter system, because one holder can suit many different lenses but not all of them by any stretch. The larger LEE-style SW150 system, for example, works with the Nikkor 14mm f/2.8, but for the 18.5mm f/1.8, you'd need to get a Lee Sev5n system. Just one system is already large to have to carry around, and the glass is fragile, so that's worth thinking about.

Graduated filters are so essential because they enable you to expose for the land without blowing out the sky, keeping the beautiful colours in sunsets and direct light. The discrepancy between land and sky during sunrise and sunset isn't always possible to fix in post-production, because the range of light values in the scene may exceed the dynamic range of the sensor. Graduated filters come in a few flavours that can really enhance your exposure. Some come with one- to three-stop filtering of the top section, while others offer up to a nine-stop transition in the graduated section.

Level your tripod and set the exposure for the land, then slip your glass into the filter holder and adjust the filter so the bottom of the gradient meets the horizon, or at least a small part of the land section. If you are using a hard-edged filter, this may take some additional time to get right. If you are combining the graduated filter with a circular polarizer, make sure the circular polarizer is the last filter in the deck (closest to the lens).

I always start with an aperture of around f/22 or f/18 and work backwards. With a narrow aperture you can also get a lovely burst from the sun, if that's a desired effect (see page 28), or if not, change the aperture to suit your intentions. Make sure your land is exposed the way you want it. Using the electronic viewfinder and the live preview option will give you a good idea of how the image will come out, so use that where possible.

Focus on the foreground just under the horizon. For this kind of shooting, always use a shutter release and have the camera on a tripod, as that will ensure you have a crisp image.

Common Mistakes

Double-check you don't have an HDR mode or D-Range Optimization feature turned on. I would also highly recommend not using Auto White Balance, or if you are, try and balance with an ExpoDisc.

An ExpoDisc is an opaque filter you use by placing it over the lens, shooting in the opposite direction to your subject, calibrating for the white, then returning the camera back to the subject. Alternatively, a handy cheat is to leave a perfectly white card on the floor, just visible in the frame, which you can crop out in post-production after using it to tweak the white balance in the Raw file.

Finally, start taking your shots, and hopefully you will capture lots of great images that require minimal post-production editing.

Notes

Put the camera into Spot Metering mode (you can cheat here by pointing your camera at the land section of your composed image); press the AEL (Auto Exposure Lock) button when you have achieved the look you want (or alternatively, use Manual exposure).

Filter Edges

Graduated filters can have different types of gradients, which are useful for different skies:

Above: Soft Edge

Above: Hard Edge

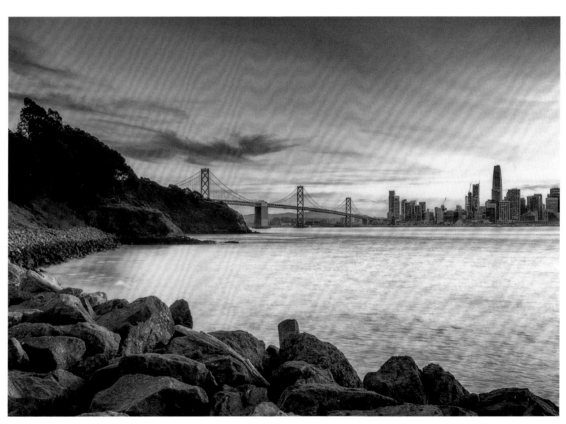

Above Right: Here, a filter has been used to control the relative strength of the sky, balancing a rich sky with detail in the foreground.

Why Polarize?

Use a circular polarizing filter to selectively highlight reflections.

The primary function of polarizing filters is to reduce glare or reflections from surfaces like glass or water (but not so much metallic ones). Secondly, they slightly reduce the overall exposure, like a neutral density filter, which will likely have the effect of increasing saturation as your camera compensates. Most photographers carry them, but not all remember to use them.

Circular polarizers (CPLs) consist of two glass elements, a front (polarizing) element rotated in relation to a quarter-wave plate, or rear glass element. Light travels in waves, and reflected light involves a lot of incident waves bouncing at multiple angles. The polarizer acts like a Venetian blind, so only one angle of light passes through at a time. Which angle gets through varies as you turn the front filter element. The image at right with the green trees over the water is a good example of what happens when you don't use a polarizer. The sunlight is flaring all over the image, causing a loss of definition.

Using a circular polarizer can be a little tricky when you're also using graduated square filters, as you want the gradient of the graduated filter to be part of the composition (it will have to remain level with the horizon), but a circular polarizer must be turned to adjust its effect. So, you need to adjust the CPL first before fitting any more filters into a filter holder system. Keep the circular polarizer at the back of the stack to maximize its benefit.

Using this special CPL glass, you can choose how much reflection you want from water or the glass of buildings. One of my favourite applications for it is reflecting the sky (especially clouds) or other buildings in the windows of skyscrapers in New York City, where I live. A CPL is one of my most-used filters, and I normally keep one on my camera at all times; even if I'm not dragging around my filter holder, I at least keep a screw-type CPL handy. It's one of the most versatile tools in your toolbox.

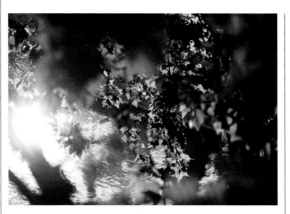

Above: This image would have benefited from both some polarized and UV filtering. The lack of either has made the colours washed out and too bright to retain much detail on the inner part of the frame.

Below: It's worth spending some money and purchasing a filter system rather than using a screw-type filter. With larger filters, you will find the glass is normally high quality and they can be used on many lenses, so you don't have to purchase a filter for each lens diameter you have.

Notes

Circular polarizers let you reduce reflected light 'noise'.

Polarizers work best when the sun is relatively high.

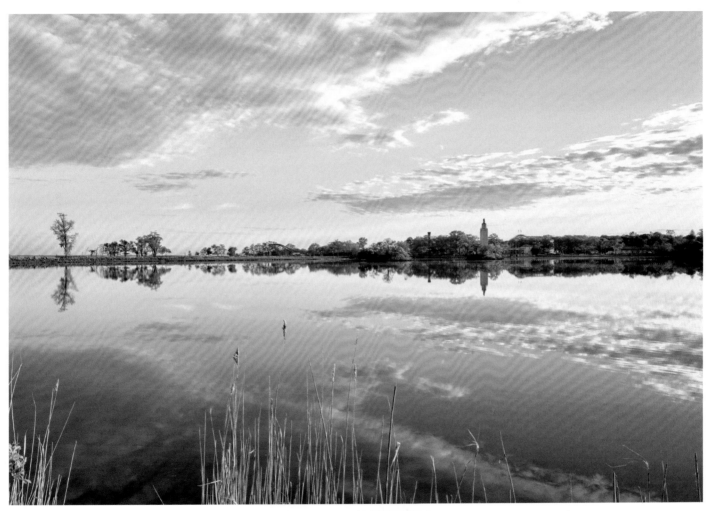

Left: The circular polarizer is turned so that the reflected image of a nearby building can be captured. Turning it to another position would cause the reflected image to disappear, and we'd see through the glass to the inside of the building pictured instead. In either case, light bouncing in other directions is eliminated to reduce the appearance of light 'noise' and make the image clear.

Above: With a small rotation of the glass, you are able to fine-tune reflections to show only light reflecting back off the reflective surface, rather than what's behind it. Here, the reflection of the sky seems as equally bright as the sky itself, and the polarizer had a saturating effect.

Composing Sunrise & Sunset

The way you frame it can take a clichéd subject into new territory.

Before setting the scene for a great landscape, a very good starting point is to ask yourself what you want to feature more: the sky, a subject on land or the land itself? Far too often, we default to the Rule of Thirds – taught quite possibly in our first camera lesson – and that's not a bad thing, but there are other options depending upon what you want to emphasize, or perhaps what your client thinks you should emphasize.

Extreme compositions can make a sky look vast or land appear long and desolate, a method I prefer when featuring a sunset or a waterfall. Because the Rule of Thirds is such a well-known guide – many smartphones display the guides by default in their camera apps – the neatness doesn't say anything to viewers. Tilting the camera downwards to capture more of the earth creates a sense of near-endless distance, while leaning it back to expose more sky can also grab attention.

While you do want to avoid putting your subject bang centre, the horizontal centre can work nicely with a sunset because it feels tidy (see image at right). Furthermore, a low sun creates long shadows which will appear to point to the light and draw the viewer's eye to it. Composing the image any other way might cause you to crop such shadows.

In summary, the sun is such a large and dominant light source that you can comfortably break the Rule of Thirds without much bother. I don't recommend you discount the rule altogether, but when you're shooting a sunset, remember that there is something in the frame that will grab the viewer's attention, and this allows you more compositional flexibility.

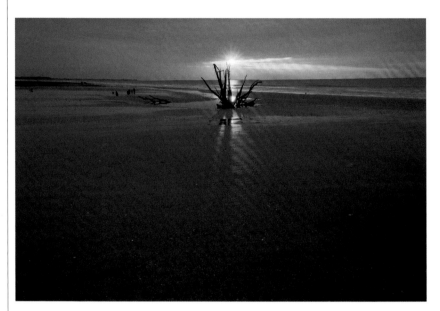

This Page: In this shot of Boneyard Beach, South Carolina, positioning the sun centrally makes it possible to use the shadows. By pushing the sky into the top of the frame, the environment seems far more extreme, emphasizing the size and emptiness of the beach.

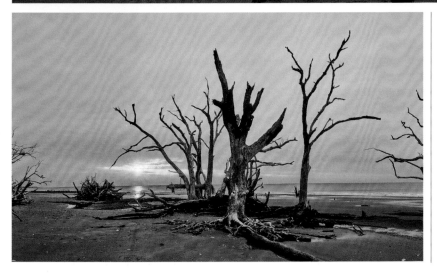

Above & Left: Although a bright-orange setting sun is a powerful subject in an image and can draw attention all on its own, it never hurts to have other elements in the frame pointing to it to lead the viewer's eye, like the lone foreground branch here.

Far Left: The sun is positioned classically in the frame, and I have moved myself on the beach to frame it using the branches from the trees. In addition, the extended root points towards the sun from the bottom-right corner of the frame.

Sunset from Another Angle

The classic sunset has a sun in it; here's a different approach.

If you can get your angles right, try capturing a sunset as a reflection in the side of a building, as opposed to the classic silhouette. It's a photo of the idea of a sunset, really.

This is the kind of photography that is made easier by the numerous tools and resources now available online. Since the most dramatic effects require a very low light in the sky, start by finding out when and where the sun will set using an app like The Photographer's Ephemeris.

Once you know where the sun will set, you have the source of your light. Next, you need to know where its reflection will be most visible. You can take a stab at placing yourself (and your camera) using a satellite mapping service like Google Maps.

Remember that light bounces off a subject at exactly the same angle (in the opposite direction) as it hits it. Light coming from 45°, for example, will reflect fully at 135°. The equation, such as it is, is known as the 'angle of incidence', or the 'angle of reflection'. Broadly speaking, the narrower the angle (the pink lines in the illustration, for example, as opposed to the blue), the brighter the reflection; but it needs to be over 45° not to light your whole subject.

The reason this technique looks so good with glass buildings is that there is a specular reflection – that is, one in which almost all the light is bounced in the same direction. Textured surfaces don't produce the same effect.

Notes

There are apps and websites that can help you calculate where and when the sun will set.

Remember that the angle of incidence (of light hitting a subject) is equal to the angle of reflection.

Right: Lower Manhattan seen in the evening gloom of an overcast day, with the sunset reflecting off 4 World Trade Center from somewhere over Staten Island.

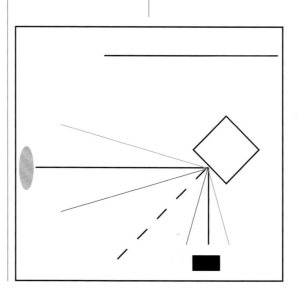

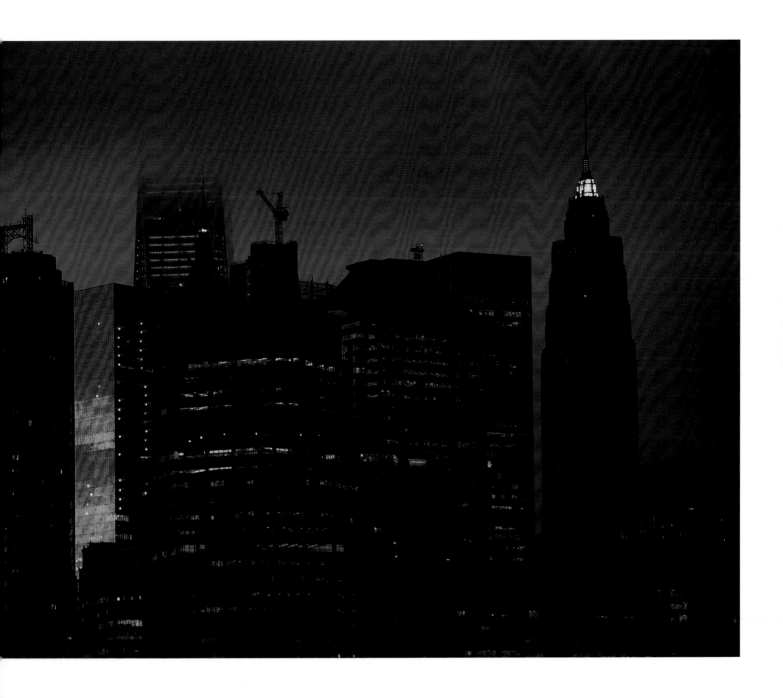

Silhouettes

It may seem a cliché, but for a pro with a stock portfolio, some silhouettes are essential.

Conventionally speaking, the subject of a photo is in the foreground, but ignoring the foreground can open up other doors. You can make some fantastic silhouettes that keep the foreground interesting enough but also leave something to the imagination.

These shots are quite simple to pull off, and with a small bit of retouching, you can make some creative images. I sell a great deal of silhouette shots into stock photography.

What is key here is working out just how much of the foreground you want to leave to the imagination. As you can see with the image of the surfers on the beach, I chose to leave in quite a bit of detail – not enough to recognize the faces, but enough to see that the surfers are fresh out of the water. You can control the degree of detail by adjusting the shutter speed, or to a lesser extent, reducing shadow density in post-production.

Silhouettes can help you create something from a very untidy scene or make a striking graphic when the foreground isn't otherwise very interesting. So, be sure to play around at sunset (or sunrise) and capture those amazing dramatic backdrops that really pop.

Don't be afraid of the saturation adjustments in post-production, either. You might feel that the examples here are somewhat over-enhanced, but – especially if you're selling into stock – it doesn't hurt to provide looks for all ends of the market, the subtle and the not-so-subtle.

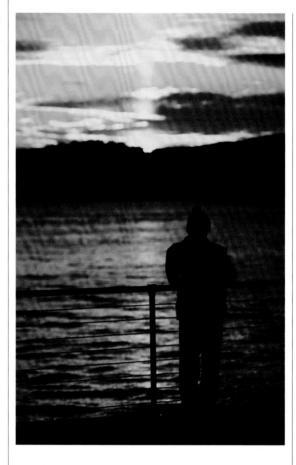

Left: Of this group of images, this has been the least successful in stock images, most likely because the extremely contrasty sky doesn't work well for designers who want an image they can place text on top of.

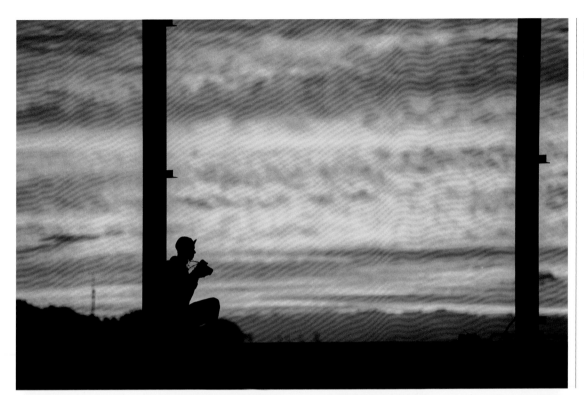

Left: A saturated sky (exaggerated in post-production), captured using an ND filter, leaves no detail at all in the subject.

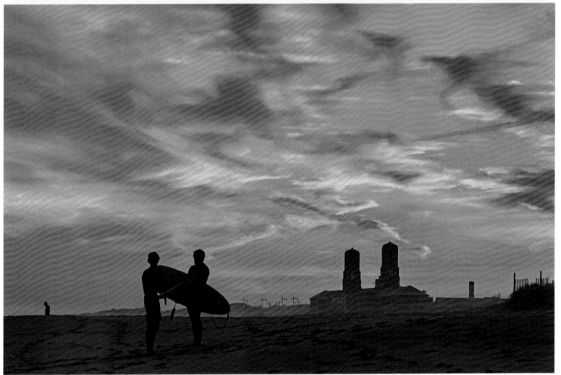

Left: Silhouettes do not have to be so absolute; here, the exposure has been for the sky, but lifting the shadows in post-production provides a gentler alternative.

The Crystal Ball

Sometimes known as a photo sphere, this can turn the world upside down.

The fact a crystal ball might have occupied the corner of your hippie friend's flat next to some overpriced coloured stones and a lava lamp is not entirely disconnected with its commercial benefit. A glass ball is a very simple lens, in pure terms no different to the elements that make up your camera lens. Of course, camera lens elements are significantly better engineered to allow for zooming, focusing and the optimization of space, but at a very fundamental level they work in the same way – light travels through them.

Where things get interesting from a creator's perspective is that you can use the ball as a focal point to give the impression of a single point of clarity, since you'll focus the camera on the ball rather than the scene behind it. Even with a relatively narrow aperture, the background slips into a blur.

It's something you'll have to make up your own mind about; you'll find that there are optical aberrations around the edges of the image in the ball and, of course, it'll appear upside down. This isn't so much of a problem as a creative choice though; by introducing the ball into the frame, you're already overtly acknowledging that an optical process is going on. It's one that gives the illusion of control to the viewer. If you opt to place a hand in the frame, you can have it appear to belong to the camera-holder, making the viewer feel in control, or – if the ball is held from the far side of the frame – it may seem more as if another power is involved.

Crystal balls are available in a number of different sizes. A diameter of around 80mm (3.15in) seems to be practical for photography – although, being a lump of solid glass, it does weigh more than many modern camera bodies.

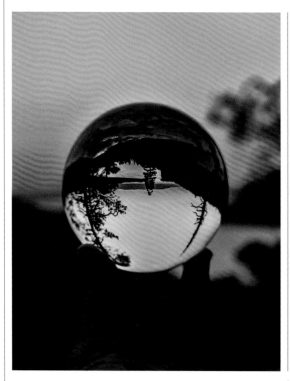

Notes

Different sizes of ball are available, but 80mm (3.15in) is a good size for photography.

This technique lends a surreal layer of depth to an otherwise standard landscape shot.

Above Left: Making the hand holding the ball part of the shot is a creative option.

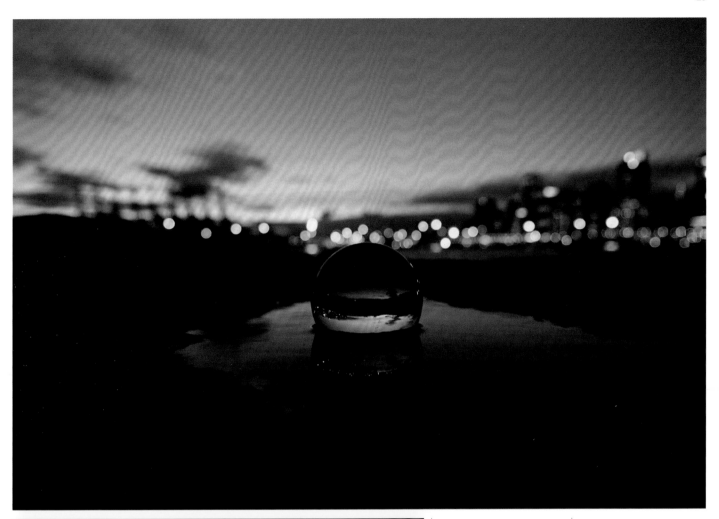

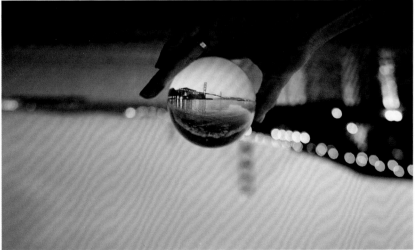

Left: The optical effect can be changed by flipping the picture so that the image rendered in the ball is the right-side up.

Above: You'll note that the ball doesn't have much of a darkening effect on the light of the scene, which makes them relatively easy to work with. Here, a glass ball is placed in sand just under the water line.

HDR Landscape

High dynamic range photography has come full circle; the new-old ways are still important.

Instead of using a filter for getting the correct exposure you can use HDR (high dynamic range) techniques, something I'm a huge fan of. HDR is a term which now extends to colour pallets, TV marketing jargon and so much more, but when it was first discovered by photographers it referred to a technique for blending a series of exposures with a consistent aperture and ISO setting, and only the shutter speed varying. While I won't cover the post-production in great detail (not least because software, including Photoshop, now handles this with user-friendly aplomb), I will guide you through the steps needed to make a great bunch of bracketed shots ready to be processed.

Chances are your camera has amazing dynamic range, and that you are used to the tools in software (like Lightroom or Capture One) that allow you to refine the shadow detail from a Raw file. One file though – even from a great camera – will not have the range you can achieve by 'stacking'. The results can be staggering.

Essentially HDR stacking involves shooting multiple images and create a single 'super' Raw file from which you can then make all the shadow and highlight detail adjustments as before, but with better information to work from.

Grab your tripod and shutter release (and wide-angle lens, a prime is best). Lock in the ISO to around 100 or 200. You don't want the ISO changing from one frame to the next, because you want the appearance (or ideally, absence) of noise to be the same in all frames. I like to shoot HDR images in Aperture Priority mode so that the depth of field also doesn't change from shot to shot as the exposure changes, but many cameras do not allow you to set the ISO manually in the auto exposure modes. Some cameras, however, like the Sony Alpha, have an option to choose the ISO you want and use Aperture Priority. Another 'cheat' on some models is to set the minimum and maximum ISO to one single speed, so even when the camera tries to use auto ISO, it doesn't change your settings.

The objective here is to have a complete set of exposures that cover the histogram from left to right in equal jumps. So let's start with a manual, equal-stepped HDR bracket.

Set your camera to A (or Av) and choose a relatively small aperture like $f/8$ or $f/11$, depending on how bright your scene is. The camera should work out a good shutter speed for the scene with Spot Metering. Now reduce the EV (exposure value) to minus 5 (-EV5). (If your camera doesn't go all the way to 5, then select -EV3). Take a shot and view the histogram. Hopefully, it should be all the way to the left (this image is generally dark). Repeat this step, keeping all other settings the same and adding 1.3 stops until you get to +EV5 (or +EV3). The histogram should now be showing a peak that goes from left to right with each exposure (depending on the scene). It should go without saying that if you're shooting JPEGs and the camera has any kind of in-camera HDR enhancement it should be turned off.

Now, let's take a closer look at that histogram. The key to a good bracketed set is to have that peak appear equal and even as it moves from left to right. Sometimes this method gives us large, uneven jumps.

Retry the same method, but with the histogram in mind. You may need to try smaller steps, with just 1EV difference between frames, or maybe even 0.3EV; but make sure you get an EV0 exposure with each set.

By getting even steps, we know the transition between light and dark is even too, this means when you get to processing in something like Enfuse or Photomatix, its easier to create better HDR images.

Notes

A tripod is essential!

Use Manual mode to lock the ISO and aperture, or use Aperture Priority if your camera allows you to set ISO manually in that mode.

AEB (Auto Exposure Bracketing) might be an option. Check your camera's settings.

Raw

A Raw file is something we might describe as containing HDR data – which generally means more information than the standard 8 bits of colour computers generally think in. That said, your images can still benefit from bracketing and stacking even when you shoot Raw files. The process laid out here is still likely to give you more dynamic range than a single Raw file image.

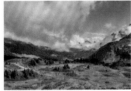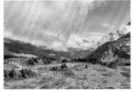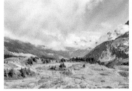

This Page: Each of the smaller images is one exposure, and the final image at top is the result of 'stacking' them to create a single image comprising all five exposures. HDR is meant to take the best from each bracketed shot.

Sunburst without a Filter

You can use special filters to create a sunburst, but you may find your lens will do it for you.

A sunburst is a lovely effect that can be created in post-production, and back in the days before editing software, cross-screen filters were commonly used. The simplest way to achieve it, however, is using the aperture adjustment on your camera. For this, you may need a tripod and camera release. Having a lens with a small aperture is best (greater than f/22 ideally). Just be sure to check the image quality at that small aperture first.

Shooting at this kind of aperture doesn't let in much light, and you'll want to expose for the sun, which can leave the foreground in shadow. You can do some post-production on the foreground, or shoot multiple bracketed shots to blend using HDR techniques.

This process makes a virtue of what could be regarded as an imperfection of lens manufacturing. The aperture is made up of 'leaves', or blades, which close and open mechanically to leave a round but not perfectly circular hole. Each of the corners in the polygon catches the sun and creates the starburst, so the more aperture components, the more lines.

To capture a sunburst, find a lovely sun scene, and compose your shot so the sun is in the frame. Set the camera to Aperture Priority mode and the ISO to 100. Start with an aperture of around f/11 or f/13 and work your way to smaller apertures with each shot. You should end up with a great burst of light around the sun. This same technique can be used for street lights or any other distinct light source.

If you want to try shooting in Manual instead of Aperture Priority mode, you can do that too. Having control over aperture and shutter speed independently can give you a wider range of exposures to choose from. Just remember to use a relatively small aperture to ensure you get the burst you're after. The more aperture blades your lens has, the more 'burst' will occur.

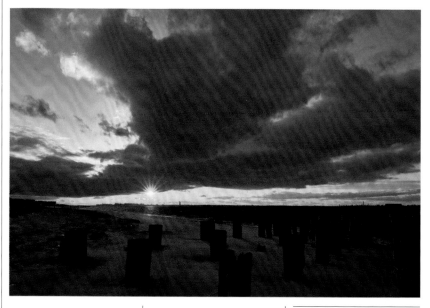

Above: Here, the foreground is quite dark because the sun is lower in the sky, but the effect of the shutter blades inside the lens are nevertheless clear to see around the sun.

Below: The blades of a lens aperture, which regulate the size of the opening.

Notes

Use a very small aperture.

This technique works best when the sun is relatively high in the sky.

The number of lines you see in your burst is affected by the lens design.

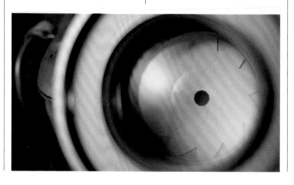

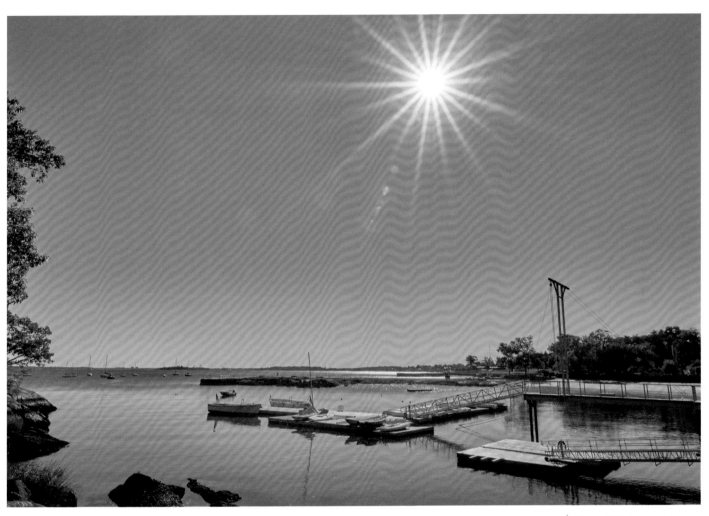

Above: With the sun higher in the sky, the effect is clear without losing scene detail. You can also see lens flare in the form of a row of circles of varying sizes; this is also an aberration which many enjoy.

Celestial

Not difficult to master, and really stands out in an era of hand held phone photography.

Looking up at the night sky has always been a huge fascination for humans, and while it's relatively easy to photograph the night sky, some know-how is needed. Even a DSLR or modern mirrorless camera won't simply record a great snap of a starscape. You're going to need a decent tripod, and you'll find a little bit of maths is going to help you go a long way.

Not every location can be a starscape. If you live near a city, you'll find the light pollution is a real issue. Clouds can present a problem too, though that should go without saying! Altitude is likely your friend, reducing the amount of atmosphere between you and the stars themselves.

A great way to plan a night shot is using the Light Pollution Map phone app or one of the well-researched university maps on the internet to find a location near you. Since these sources are crowd-sourced or provided for free, their accuracy cannot be guaranteed, but I have found them to be pretty useful. Professionals will also need to check whether commercial photography is allowed – it is often restricted or requires a permit, even in national parks.

Aside from planning your location, you'll need to check your bag for a couple of bits of gear: don't forget to pack a tripod, a cable release, a torch with sufficient batteries and some bug spray. If you're setting out into the big beyond, you should also let someone know where you are going.

A good starting point for shooting starscapes is an aperture of around f/5.6, a shutter speed of 15 seconds and an ISO of 400. You can review and push the ISO back, but you probably don't want to go up from there, lest you capture a noisy sky. Assuming, too, that you're looking to capture a starscape, rather than star trails (see page 32), then you'll need to restrict your shutter speed so that the apparent motion of the stars caused by the earth's rotation isn't exposed. The solution is to follow the 500 Rule: 500 divided by the focal length of your lens is equal to the longest

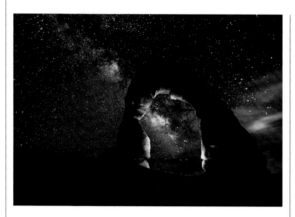

exposure possible before stars trail in the final image. It's not a hard and fast rule, but it's a good guide. This 'rule' dates from 35mm days; if you're shooting with a crop sensor, 400 divided by your focal length is likely a better bet.

Here's how it works: if you have a fixed 24mm lens on a full-frame camera, for example, 500 divided by 24 is 21 (seconds). You can attempt, say, an exposure of 20 seconds. Review the image on-screen, zoom in on a star and if you see trails, then reduce your exposure time. If the scene gets a little dark, then bump the ISO up slightly to compensate.

Remember, long exposure works best when you use a trigger or remote trigger. One tool I use all the time is the MIOPS remote trigger, which can be fired off from a mobile phone. One advantage here is that you can dial in the release just as you please rather than using a stopwatch and a release cable. There are many devices on the market that do the same thing, but a wired release can equally do a great job. If you don't have a remote release, use the ten-second timer; this will give the camera time to stop vibrating after you press the shutter button and before the sensor is exposed.

Notes

Use a light pollution map, such as darksitefinder.com.

Pack a tripod, a cable or remote release, a torch and bug spray

Don't forget, stars 'move'! Use the 500 Rule.

Above Left: In this shot, no star trails are visible; the exposure has been for the longest period possible without such lines developing, though we did pick up a shooting star.

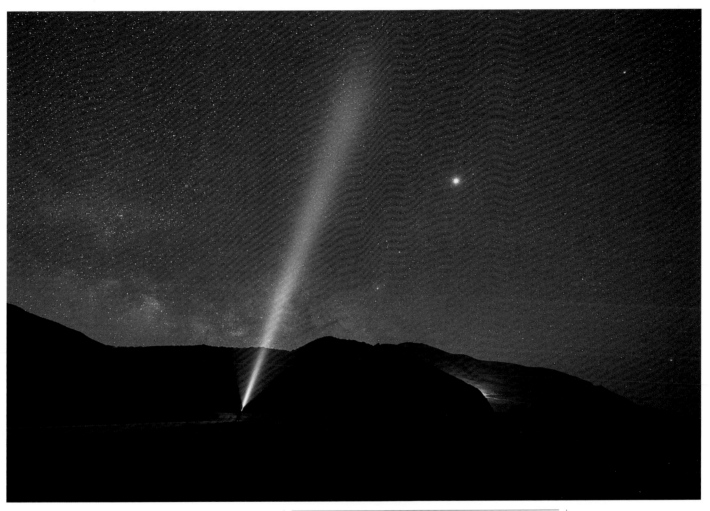

The 500 Rule

$$\frac{500}{\textbf{Focal Length} \text{ (mm)}} = \textbf{Max Shutter} \text{ (seconds)}$$

Above: A torch provides a meteor-like effect.

Star Trails

Starscapes, plus the application of a little time.

Ever seen those pictures where the stars streak across the sky in a big circle, making the camera seem like it's spinning with the earth? (Hint: It is!) These are star trails. The effect is striking, and these 'star trails' are great fun to capture, but it requires a lot of patience to get a successful shot.

Again, you will need a great tripod, a shutter release or automated release tool, and because we are creating very long exposures here (maybe over two hours), your camera must have a Bulb feature within its shutter speed options. The alternative is exposure stacking (read on).

Finding a suitable location is also key. I highly recommend finding somewhere with a foreground to make the image interesting: trees will work and are easily found, but an isolated building or an interesting structure or land formation will be even better. Use all the same processes finding a location as you did for the starscape (page 30). Without question, proper research is one of the keys to success for any nighttime photography, but for star trails, you also have to keep an eye on the weather for clear skies.

In the dark, it is not easy to get autofocus to work, but there are a few ways to nail tack-sharp images. If you are including a building or a tree, use those to focus on. If the camera is struggling, then use a flash to light up the object and then try focusing again. If you are using a wide-angle lens, the foreground and the stars will probably both be in focus, even at a very wide aperture. For a lens such as a fisheye or a super-wide angle, set your camera to infinity using manual focus.

You will shoot your images using the Bulb feature, if your camera has one. Set the aperture as wide as the lens will allow, then set the ISO to somewhere in the 100–800 range (depending on your sensor's high-ISO performance). Start with a 30-second exposure. Shoot an image and review it on-screen, zooming right in to 100 percent. If there is too much noise, then drop the

ISO down and reshoot. You could also shorten the exposure time and try again.

Image Stacking

You may find a single exposure leaves you with a 'noisy' image, otherwise known as ISO noise, which makes the image a little untidy, especially when cropped. If you find this unpalatable, then instead of creating a single shot, you can 'stack' images in post-production using commercially available software. For this method, you will be shooting at least a few hundred frames, so take a few spare SD cards or storage cards for your camera. Also you will need a traditional shutter release, rather than an electronic remote or trigger device.

Set the aperture as wide as possible. *f*/3.5 is sometimes enough and also keeps things sharp. Set the ISO to around 800, and check a few exposures at 30 seconds.

Change the shooting drive mode to Continuous, which means your camera will shoot another frame as soon as the last one has completed and been written to the memory card. You'll need to lock the button on the shutter release to keep the shutter engaged; to do this, there should be a slider on the device that goes into a locked position.

Sit back and let the camera do its work over a couple of hours. Once you have a good collection of images, you can stack them in software such as StarStaX, which is free and available on all computer platforms. This will give you the best parts of each exposure combined into one image, without the noise.

Notes

Use a light pollution map, such as darksitefinder.com.

Pack a tripod, a cable or remote shutter release, a torch and bug spray.

Shoot in Bulb mode.

Review your first shot at 100 percent to check for noise.

StarStaX is a multi-platform app for stacking and blending images.

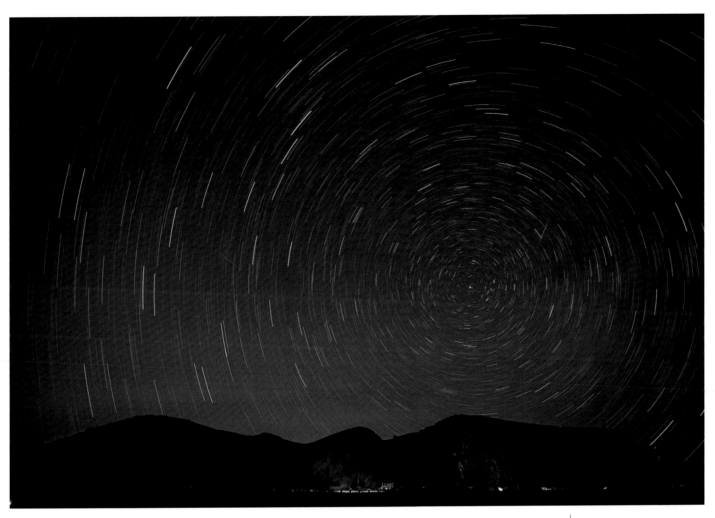

Above: Star trails are created by the earth's movement during a very long exposure (or numerous shorter ones merged in software).

Shooting Through a Telescope

When a telephoto lens just isn't enough, a telescope will do.

Want to get closer to the moon? See the International Space Station? Well that's easiest through a very long lens – 400mm or longer with a 2x extender; or through a telescope.

One advantage of using a telescope is that some models are 'auto motorized', a feature which helps you locate planets and other great finds across the night sky using computer software. In some cases, telescopes can see much farther than a camera lens, bringing another advantage.

The Afocal Method

One way of shooting through a telescope involves, basically, letting the camera look down the shaft of the eyepiece on the telescope. You're focusing the camera not on the moon or planets, but on the eyepiece. It's a bit of a DIY solution and, predictably, you'll need to either hold the camera by hand, mount it on a separate tripod or buy some grip to hold the camera directly onto the scope.

In this kind of photography, a camera with an electronic viewfinder is a real boon. Not only can you use focus peaking to make sure you're getting perfect focus, but you can tether with a software tool like Capture One so you can nail the focus each time. This method relies on the telescope being perfectly focused before the camera gets involved.

The T-Ring Method

For the T-ring (or T-mount) method, you attach your camera to the telescope using an adapter. This will effectively make your camera the eyepiece, with the image headed straight for your sensor. The T-ring is a very basic, standard lens mount for telescopes and microscopes – a 42mm screw with no means for the transmission of electronic information (focus, etc.). Celestron adapters unfortunately only support Nikon and Canon at this time. With some clever work, however, you can attach the Nikon or Canon T-ring

to a Metabones adapter. (Metabones produce mount adapters to make different manufacturers' lenses and cameras compatible with one another.)

Once you have connected the camera and telescope, you simply need to take your shot. Again, you can tether your camera to a program like Capture One to nail the focus and composition.

One other benefit of using the T-ring method is the camera is stabilized by the telescope mount itself, meaning no extra grip is required. Just make sure your telescope is on sound footing so the extra weight of the camera doesn't upset the balance.

For bright subjects, like a highly reflective moon or planet, you may need to close up your aperture a bit.

Reflection v Refraction

As soon as I talk about shooting the galaxy, I get asked which kind of telescope to get. There is no right or wrong answer, but reflecting telescopes are considered the best for photography professionals, for good reason. Reflecting telescopes (which are bigger and stubbier) use special mirrors that reflect light and form an image in an eyepiece on the side of the telescope. This technology removes almost all chromatic aberrations (faults which are common in refractive telescopes).

A refractive telescope – a long tube with an eyepiece at the end – nevertheless remains the most culturally well-known type, even though the technology really belongs in Galileo's era. These long, thin tubes have narrower openings for light. They do have a couple of benefits, though: they are lower priced; and for things like comets, the refraction style is very handy due to its light frame – it can follow a moving object more quickly and easily than its reflective cousin.

Notes

A 400mm lens with a 2x extender is a good alternative if you're not ready to commit to a telescope.

The rotation of the earth means you can't use long exposures (unless you want star trails).

Reflective telescopes let in more light than traditional refractive ones.

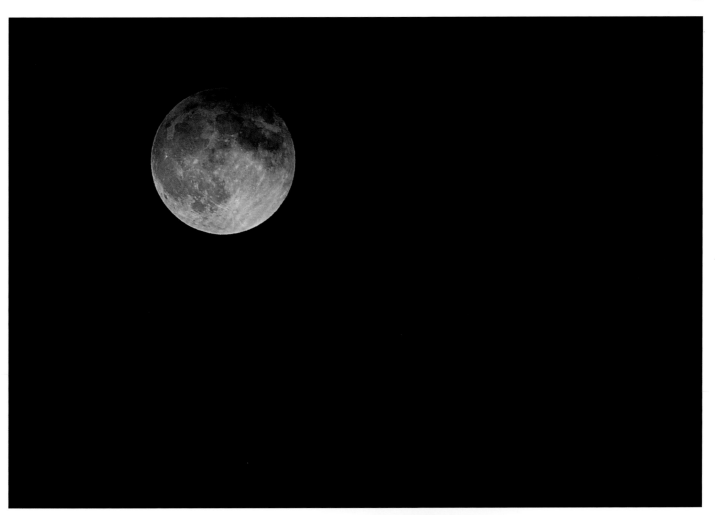

Above: The moon captured through a 400mm lens.

Left: A T-mount adapter is not a technically complicated device, simply having a 42mm screw fitting on the inside.

How to Capture Lightning

You'll need some luck, but you can certainly help steer the luck with hardware.

Creating lightning images is tricky – you need a good portion of luck, some equipment and a sense of adventure. Not to mention an accurate weather report. Some safety steps need to be followed. Try and be as far away from the storm as possible – waving a tripod around in the thick of a storm is never going to be a great idea, plus that distance will dramatically increase your chances of being able to capture the storm.

You will need a tripod, a camera trigger with a lightning feature, a camera with a PC-sync port and a light meter. Some would say you don't need the light meter, but I think its a very important tool in lighting conditions that can change quickly.

Set the ISO to 200 and then set your exposure. AWB (Auto White Balance) is fine for the most part, although you might want to try a slightly cooler Kelvin than the temperature the camera chooses. Whichever method you choose, be sure to get a few good exposures of any foreground interest. If you stack your shots in post-production later, you'll be glad you did this.

Method One

The trigger device is a great cheat. The Lightning setting is quick enough to set the camera off at the right time. Many products also have settings for triggering the camera with sound or laser, plus time lapse and HDR features too. They're great gadgets to have.

There are a few caveats: the Lightning mode is probably only around 90 percent accurate in detecting a strike, plus the strike has to be active long enough for the shutter to be released. In other words, you need the lightning to linger for the milliseconds that it takes for the trigger's signal to open the shutter. Still, these risks aside, the trigger takes something essentially impossible and makes it more than likely, assuming you have the patience. Set the camera's drive mode to Single Shot and wait for a strike to occur.

Method Two

You'll need an old-fashioned cable release for this method, which is simply to use long exposures and hope, increasing the odds of capturing a strike by shooting a lot. There will be plenty to delete. Set the exposure according to the light meter, this time using an ISO of 100. Change the drive mode to Continuous (so your camera will shoot another frame as soon as the last one has finished), and lock the cable release using its slider or wheel. Meter the light, adjusting the f-stop until you get around 2 seconds of shutter time, then start shooting. You may need an ND filter to lengthen your exposures.

Blending

Maybe you didn't get that one perfect frame. You can stack, or combine, multiple shots to create one great image. The post-production process is pretty straightforward: start with your foreground exposures, blending and editing to make it look sharp and 'pop', especially if you're using a city skyline as your foreground. Then blend in the lightning strikes you want to include along with your foreground using Overlay mode. Stack as many strikes as you feel look good, and your images should be complete!

Notes

Get a lightning trigger. You'll find all sorts of other uses for it too! Or, if that's not in the budget, go for Method Two and use a cable release with a lock.

Shoot on a tripod.

Shoot in Raw to maximize post-production flexibility.

Be sure to shoot the foreground for blending later.

Left: Set your trigger to its Lightning mode. There should be an option to adjust the sensitivity. On my MIOPS, I find 83 is a good setting. Make sure the sensor is pointing at the sky; use an adjustable light stand to direct it if possible. You can also place a very fine plastic bag over the top. If you want to test it, fire off a flash gun pointing away from the sensor. It should trigger the camera.

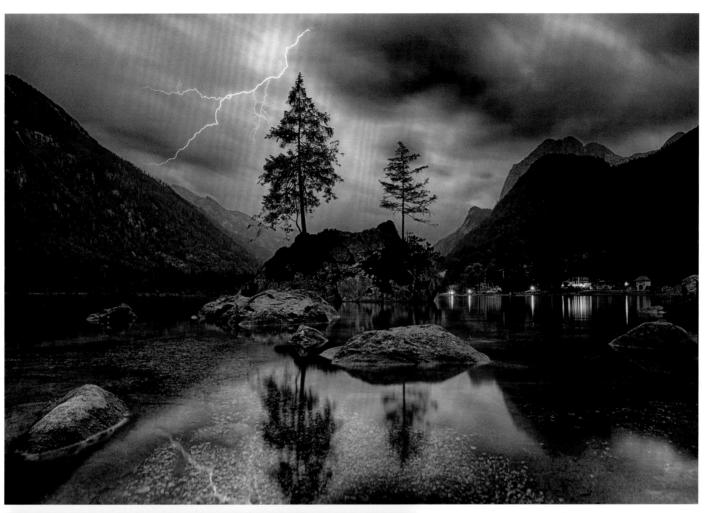

Above: This relatively long exposure allowed time for the clouds to move and the water surface to appear settled, but it was not so long that multiple strikes showed up.

Left: This shot did not rely on a long exposure and luck, but rather a lightning trigger.

Using Tilt-Shift

A tilt-shift lens is a must-have. It can create striking images of landscapes (and many other things besides) and is an absolute joy to work with. However, understanding how they work is very important to appreciating the investment.

Unlike a regular lens, a tilt-shift allows you to achieve a depth of field similar to shooting with a wide-open aperture on an f/2.8 or more lens, except you can do it at any aperture and at a much farther distance. Although it takes some trial and error at the scene, the result invariably makes the real world look a lot like a model photographed using a macro lens, an effect which can be quite attention-grabbing. (This effect is particularly interesting with aerial photography.)

Another of many benefits is that you can control the 'keystone', which is the convergence of lines within the frame when you point a camera with a regular lens up or down. Normally, tilting your camera up to photograph a tall building, for example, causes some distortion, especially with a wide-angle lens. The bottom of the building appears a bit larger than life and the top smaller. The tilt function on a tilt-shift lens allows you to keep your focal plane (sensor or film) parallel to the building but tilt the lens up so that it still includes the entire building in the frame. This eliminates the inward distortion of the building's lines.

And, perhaps a happy side effect: tilt-shift lenses, when used in the normal position (no tilt or shift applied), project an image that is edge-to-edge sharp. Most lenses cause a little bit of distortion around the edges of an image, but the tilt-shift's relatively big image circle means very little or none of that.

Right: The tilt-shift lens creates a much-exaggerated focal plane, which makes the scene look like a tiny model.

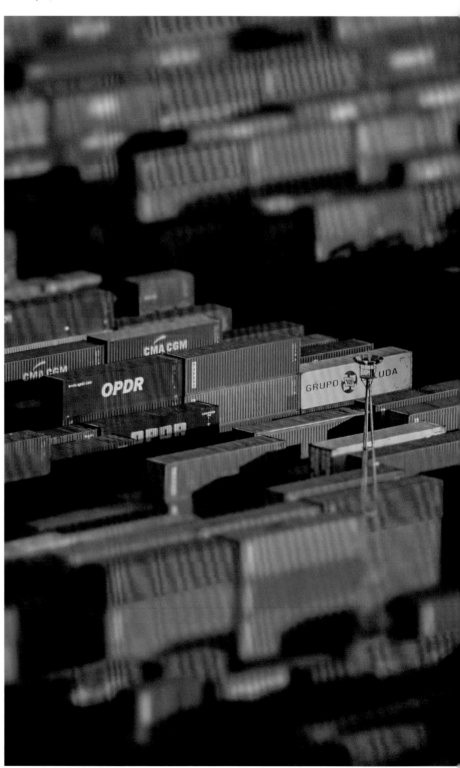

Tiny Planets

When you want to give the impression of an infinite landscape, make it a planet.

This is one for the post-production enthusiasts. It is an effect that was briefly very popular when a Photoshop whizz first discovered it, but is no less useful now. In fact, it's probably rather more useful now that it's not at the forefront of many people's minds.

You need to begin with a panoramic photograph which captures a full 360° view. (It doesn't actually need to be a 360° image; you can opt for whichever makes the view most aesthetically pleasing, but 360 has a certain logic to it.) 360 or not, you can achieve this with a camera locked on a tripod. Take a frame, rotate the camera leaving a small overlap between frames, shoot again, and then stitch the images using the Photoshop Photomerge tool. When shooting, use Manual mode so you get consistent exposures – it is a lot easier if the sun is nice and high in the sky and away from your view.

Once you have the image, open it and ensure the horizon is absolutely level. Fix it if not. You then need to distort it into a square shape. For example, if you have a panorama 10,000 pixels wide and 2,000 tall, you're going to make it 10,000 by 10,000, so you need to disable the 'proportional' chain icon. You also need to flip the image vertically, so that the sky of your original composition will find itself at the outside of your finished image.

Finally, go to Filter > Distort > Polar Coordinates and apply the default 'Rectangular to Polar' method in the dialogue box.

Some composition points: these pictures work well when there is nothing complicated in the immediate foreground. It also helps a great deal if the scene is evenly lit and the sky is evenly shaded; you can of course correct it to some extent in software, but it is nicer not to have to.

Right: What happens when you work with an uneven sky.

Opposite: A tiny planet taken from an aerial view.

Below: The technique can also be used in 'reverse' if the image is not flipped, placing the sky at the centre and the horizon at the edge.

Notes

Begin with a 360° panorama.

Stretch the image (turn 'proportional' off) to a square.

Flip the image vertically.

Apply Filter > Distort > Polar Coordinates.

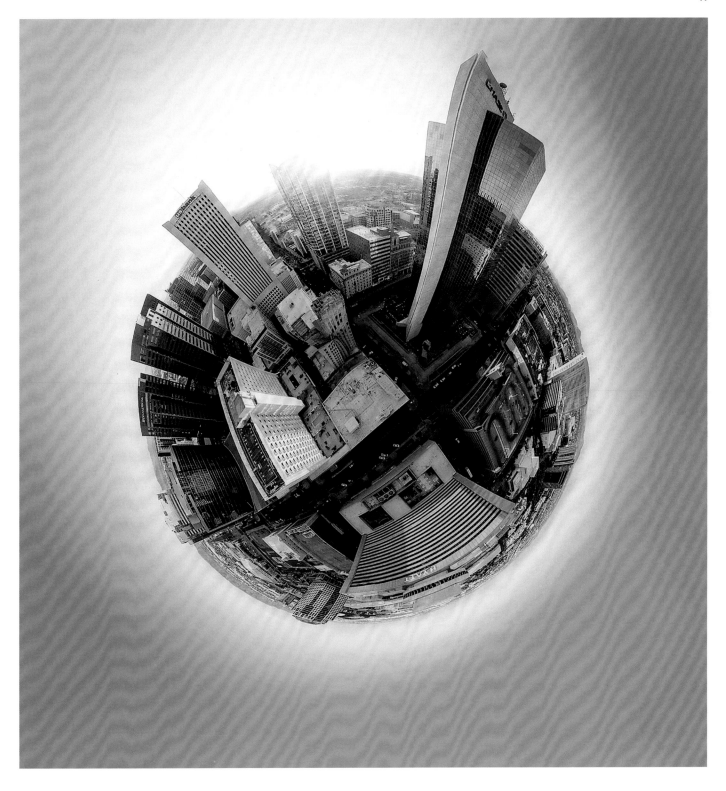

Fresh Street Photography

The world is overwhelmed with street photography shot on phones. Stand out.

The more flooded a photographic genre becomes, the more difficult it is to stand out. And one of the most fashionable areas for enthusiasts is street photography, a broad term used to describe a significant swathe of documentary images or even just holiday snaps. Commercially, though, it's a significant area to keep your eye on as plenty of clients look for something that feels real. Creating that feeling typically requires a relatively wide-angle lens, which produces images full of dimensionality and a feeling of 'being there'. (The iPhone main lenses have an EFL (equivalent focal length) of 28mm, so for many, that is now the standard perception of the world.) Your camera, however, will have better optics!

Another way of reaching the street-smart audience that doesn't require you to abandon your telephoto lenses is to utilize another aspect of visual language: tone. Specifically, shoot in black and white. It's effective because it's timeless, and because it lets you shoot for the frame rather than worry about colour.

The image of the man standing by himself (opposite), taken in New York by the Lincoln Center, works because the lines in the pavement and the sign lead the viewer's eye to the solitary figure. There is a clear conflict with the 'no standing' signpost, and while it might not be a classic, on-the-ground street shot, the image has been hugely popular and has sold plenty to collectors and galleries alike. It does not conform to all the rules, but it does draw attention naturally, especially as there is an obvious lack of both detail and anything to view in the top-right section of the image.

The other image on the opposite page, taken at David Geffen Hall (just round the corner), draws your attention to the early morning tourists by using the pattern on the ground to lead the viewer into the pack of people. The line of the building above could be distracting and could easily be cropped out, but the sense of context would be removed, which is just as important as the final frame and overall composition, so I left it in.

You should also be as aware as you can of shadows. Take a look at the shadows in the street shot below, taken in Innsbruck, Austria. The light and composition all work together to lead the viewer's eye up the street and ultimately to the rear of the shot. It intrigues the viewer to want to see what's beyond the bend.

Notes

Street photography is everywhere.

While 50mm is the traditional street photography lens, 28mm might seem more natural to younger viewers, thanks to the iPhone.

Never forget the impact of monochrome.

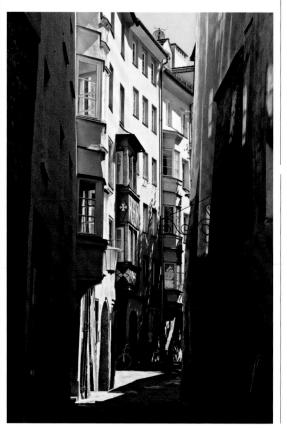

Left: A street in Innsbruck, Austria, exposed with a dark foreground to lead your eyes into the frame.

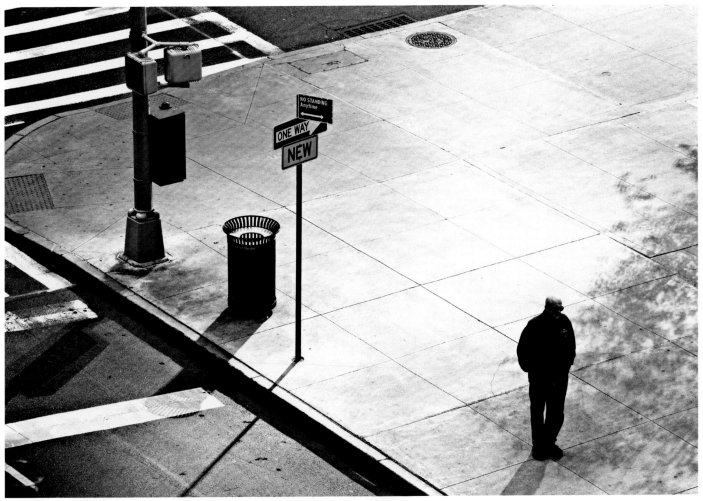

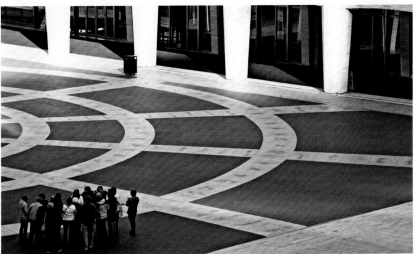

Above: This image was captured near sunset, but the desaturation concentrates the viewer on the details. The lack of distractions gives you time to find the 'no standing' sign.

Left: Don't be blind to curved lines. Your camera will often draw Rule-of-Third guides on the screen, but here, the curved lines in the floor design do a lot more for the image.

Low Angles

Looking up always creates a different perspective and can be commercially useful.

The worm's-eye view is far too often overlooked by photographers. It is a simple and instant way of changing your perspective, which can work with any lens and most conditions.

There is a reason that looking upwards is associated with awe and wonder, and looking downwards is associated with gloom and depression. Yet, strangely, we tend to keep our lenses on a fairly horizontal plane, lifting our perspective only to keep tall buildings in frame. Why not make sure you get a few shots in which you completely ignore the need to document the whole scene, but instead convey that sense of hope?

From a commercial standpoint, there is much to be said for it; alternative views stand out in stock libraries. You're also looking up at the sky, which means you'll be able to compose your image to create a lot of clean space, which designers like because they can add type to it.

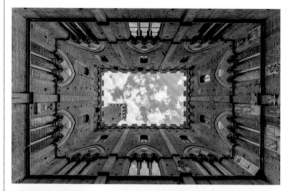

Left: This gorgeous, symmetrical, pleasing new perspective on old architecture makes for a striking image.

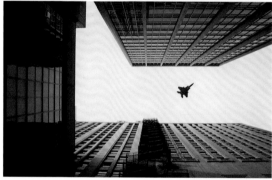

Left: A certain amount of patience and knowledge of local flight paths can yield even more interesting results.

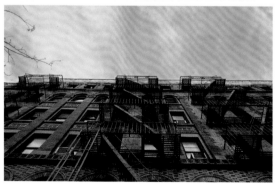

Left: It's nice to make a virtue of converging vertical lines, rather than to process them away.

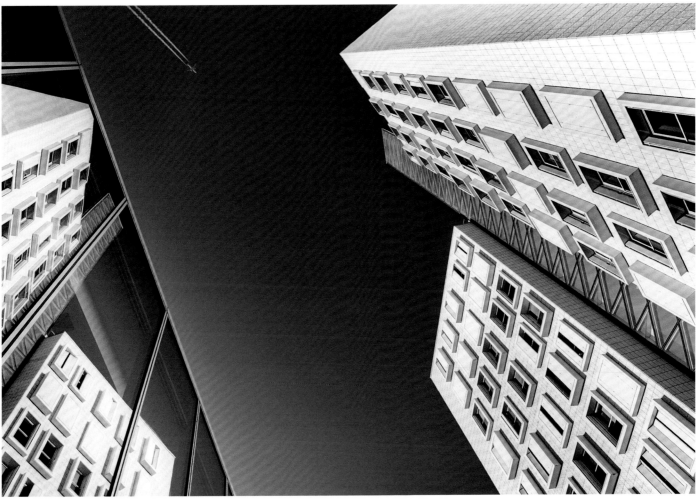

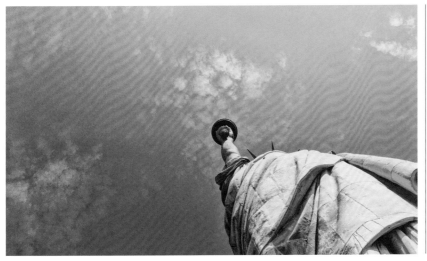

Left: A view of the Statue of Liberty that it occurs to very few of the visiting tourists to capture, but with a lot of potential as a stock image.

Above: Here, the photographer points the camera towards the sky, using a circular polarizing filter for a perfect reflection. This unconventional perspective together with the plane's condensation trail make a clean and commercially successful shot.

**People &
Lighting**

Lens Whacking

It's not whack-a-mole with your expensive glass, but some rules are broken!

Lens whacking is a modern term given to the technique of controlled light leaking. Those who never shot on cameras of old with film might not be aware that some cameras didn't seal the film inside away from the light very well. Alternatively, sometimes the light protection around the film casing failed. Because film is very light-sensitive, either of these scenarios would result in light 'spoiling' the resulting images in an unpredictable and uncontrollable way.

Light leaking was always considered a problem, but these days, as with so many things, there is some nostalgia for that previously undesired phenomenon. Indeed, it can be used to creative effect, and it's even a popular look.

The technique for creating an intentional light leak with modern digital cameras is a little more controlled, but the result is almost the same. If you tune your own technique, you can get some amazing results using your favourite locations as backgrounds.

While I have used light leaks in other ways and for other applications, I find that landscapes and portraits especially have some amazing possibilities.

Technique

You will need a quick, steady hand, a tripod and a shutter release. I would also recommend lens whacking with a prime lens rather than a zoom. This way you won't bump the zoom ring while the lens is off the camera slightly, which gives you one less thing to worry about. You may need to tell the camera that you are happy for it shoot without the lens attached; check your operation manual for this setting.

Place your camera on the tripod and set the Manual exposure to around 1 or 2 stops darker than you would normally. An easy way to do this is to use Aperture Priority and set the f-stop to around f/8, with ISO set to 100, and then change the EV to -2 stops. You're aiming for a one-second or longer exposure to give you time to pull the lens away. This means you

might want to try this technique in low light at first, when you will naturally have longer exposures to work with. You will become quicker as you get used to the technique, but it is a great start. Focus your scene and turn off autofocus as well as any Image Stabilization feature your camera or lens may have.

Place the shutter release in your right hand and hold the lens with the left. Make sure the lens is against the body of the camera and engaged but that the lens lock is released. As you open the shutter, move the lens away from the body enabling a small about of light to breach the flange. As you do this, be aware that you will shift the focus, so using a shallow depth of field may mean you get an entirely blurry scene. Using a smaller aperture will remove this issue somewhat.

Changing where you separate the camera from the lens will move the placement of the light leak, which takes some time to master. Trial and error and experimentation are the name of the game here.

Notes

Don't make this your only shot; get some with the lens on!

You might need to enable detached lens shooting in your camera menu.

You can blend multiple leaked shots for an exaggerated effect.

Above: Downtown Monterey, California. Both images had the same setup, with the camera on a tripod, a shutter release in one hand and the lens in the other. The only differences were the shutter speeds, and the direction of the light leak. You can get multiple leaks into the image by blending two images together. The only challenge here is getting the focus right.

Right: These two portraits were taken at the same time. The difference in appearance is down to two different white balance settings, which made for different colour temperatures.

Side Lights

Create an ominous look with two evenly balanced lights.

There are lots of reasons you might want to capture a less-than-friendly look in a photograph. Or, maybe you want to create an air of mystery.

The extent to which you make your model look sinister rather than mysterious depends on how soft the light is and whether it catches the eyes. Compare the examples on these pages; in the image on this page, the model's form is revealed by a soft light from a source a little behind him, so that just the edge is visible in shot.

The man on the page opposite, however, doesn't just look more threatening because of his pose, outfit and face paint (though these are all contributing factors), he is also lit using harsher lights. Specifically, smaller softboxes which were somewhat nearer the subject and positioned a little farther forward, so that the light reflected in corners of his eyes. We know there are eyes there, but we can't see any detail, making the subject look a little unnerving. Using two identical lights and a straight-on pose is essential here.

In the shot directly to the right, the model's right shoulder has a little more light on it, and he is slouching unevenly, all of which contributes to a sense of intimacy or relaxation – definitely non-threatening, whatever the pose suggests to you. The poise and sense of purpose in the image opposite, on the other hand, conveys strength. Even the hoodie the model is wearing has been carefully positioned so that it is as symmetrical as possible. No one has a perfectly symmetrical face, not even this model, but the suggestion of symmetry creates a more ominous effect and draws attention to the small gesture of his raised eyebrow.

Notes

Identical lights opposite one another on either side of the subject create an unnatural symmetry.

An uneven, natural-looking pose with asymmetrical lighting can still convey a sense of mystery, but without the ominous feel.

Opposite: Lit from the sides, but softly and unevenly, this composition asks questions and does not suggest aggression.

Right: The styling contributes to the apparent threat, but the effect is completed by the lighting. We can see enough of the eyes to feel we're being looked at (the model is looking straight at the lens).

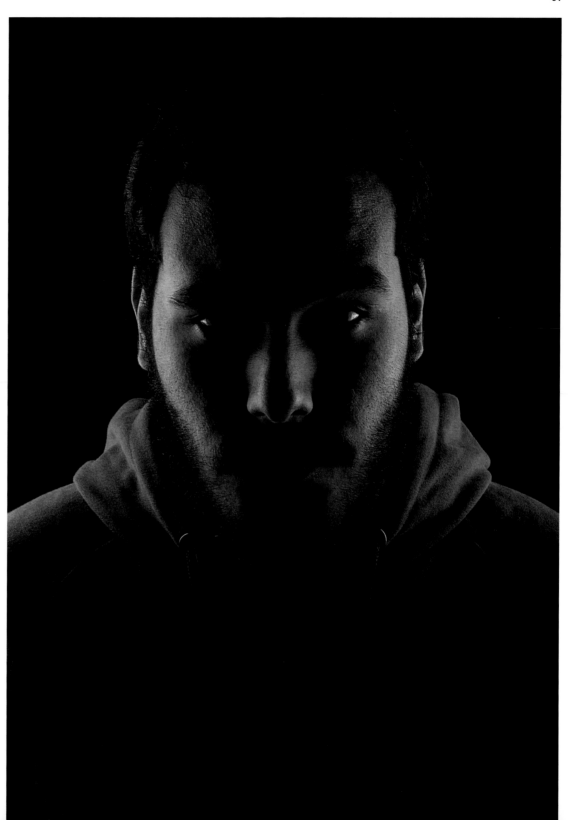

It's All in the Eyes

Make sure you can see exactly what is reflecting in the subject's eyes.

When looking at a portrait, we are drawn to the eyes. Eyes are communicative, and they're a significant part of the unique facial features that we use to recognize people, so there is no surprise there. Something that often reveals professional (or semi-professional) photography is the positioning of an obvious, unnatural light reflected in the eyes.

You can affect the sharpness of the catchlight (the reflection in the eye) with distance and aperture. Since the catchlight is a reflection, it can be softened by using a wider aperture, even if you're focusing perfectly on the eye – the reflected light having travelled rather farther.

Given that you're likely to see reflected light, you should turn this to your advantage. What is it that you want your viewers to read into the image? The circular reflection of a ring light can actually pose you some problems with lighter eyes (like blue or green) since it can cause a slightly unnatural halo around the pupil which looks strange if it lines up with exactly with the edge of the pupil. The bright glint is nonetheless engaging, it makes you feel like the person in the picture is looking back at you and serves to remind you of the shiny quality of a real, living eye.

Embracing the effect but moving away from the classic ring (which, thanks to overuse in YouTube makeup tutorials is starting to look a little tired) or softbox shape is definitely something to experiment with. In the other two examples here, we see a simple straight line, and most surprisingly of all, a triangle, a distinctly unnatural shape which ends up dominating the image. If you're looking to grab attention, even in monochrome, this is an area to experiment in.

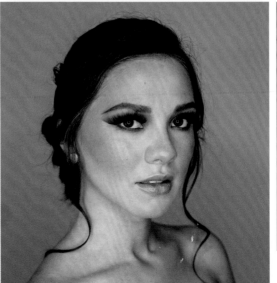

Notes

Catchlights are crucial to an engaging portrait.

Don't be afraid to experiment with different shapes of lights.

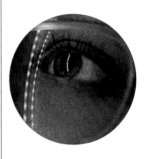

Left, Top: The LED strips reflect a single line in the pupil and further lines in the model's glasses.

Left: The standard ring light is reflected directly around the model's pupil. It's striking but too common to be really special.

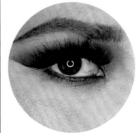

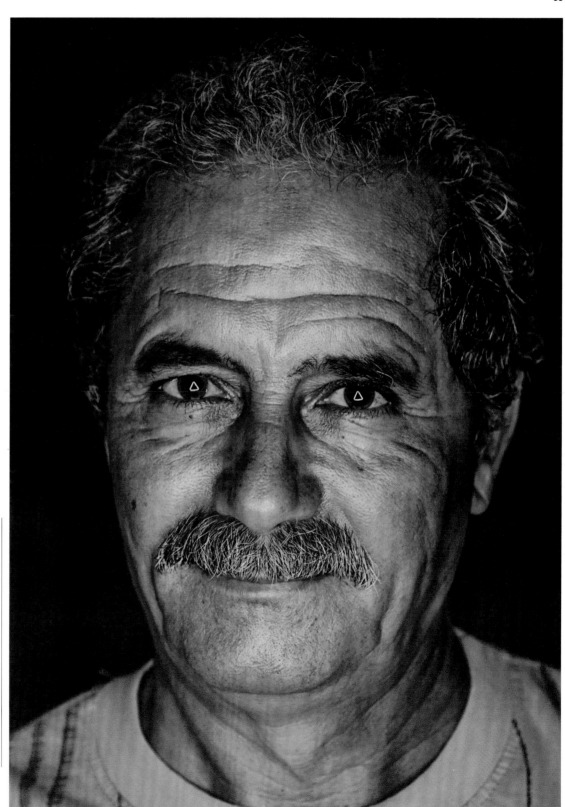

Right: Shooting through a triangle of small strip lights creates an even light over the subject's face, just as a ring light would, but results in a more unusual and interesting catchlight.

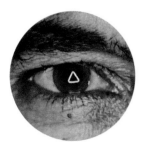

Make a Rembrandt Anywhere

Eliminate ambient lighting for a pro portrait without the studio.

The ability to create a dramatic portrait is a fantastic tool to have in your belt, since most clients would prefer to have a strong look for themselves or their models. This technique, named after the Dutch painter, involves lighting the subject from the side as he used to do, creating a shadow which emphasizes the shape of the face. It is thought to be more flattering to people with a round or fuller face.

All you need to pull it off is a more powerful flash light than your ambient light, so 'anywhere' still rules out very bright locations. Position your one key light approximately 1.2–1.5m (4–5 feet) from the subject, at a 10 o'clock or 2 o'clock position. Position the subject's body so that one side of their body and face is dimmer than the side facing the key light. Bring the light close to the subject, maybe a little closer than you would in a studio setup, and place it around 0.3–0.6m (1–2 feet) above them at most, enough to wrap the light a little.

The trick here is to have lots of strong light, a small aperture and fast shutter speed to stop ambient light hitting the sensor. High-speed sync is helpful here, but it's not crucial.

Positioning the light is only one element of a successful shot, though. It is also important to control the light spill – the light from your flash or strobe that does not hit your subject. You don't want to be lighting the background and creating a shadow, after all. There are a few ways you can achieve this.

The simplest way to control spill, with the least amount of gear, is to use your speedlight as the light source and place a grid on the head of the flash. MagMod make a super-handy line of flash modifiers that can be stacked onto the flash head using magnets. Or, if you already happen to own a strip light (with grid) or softbox, you can use a speed-ring adapter to mount it onto your speedlight. A strobe is ideal if you've got a portable one, in which case, you can apply any of the following to it: strip light, softbox, or even an octobox modified to be shaped like a strip light.

Broadly speaking, your aperture setting controls the amount of flash hitting the sensor, and the shutter speed controls the amount of ambient light hitting the sensor, so there may be times that you will need to change the shutter speed even after you have nailed the exposure. Since we are trying this on-location, we have no idea what the ambient light will be like.

Method One

For this method we are going to use a high f-stop such as f/13 (or greater), a low ISO and a fast shutter speed of 1/250 (or whatever your max sync speed is). If you have access to high-speed sync, enable it and set the shutter speed to 1/1000 of a second. Use a meter to measure the light and adjust the flash power until you have enough power to get to 1/1000. So, we have controlled the spill of light to hit just the subject, we also have lots of light and a small f-stop so light drop-off is there in abundance. Start shooting, and you should get a lovely, dark background.

Method Two

Set the flash to its most powerful setting, and meter at ISO 100, right under your subject's chin. Dial in the result and take a shot. If you can still see the background, then make the f-stop smaller and bump the flash or strobe up one stop. Repeat this until you have no background and only your subject in frame. There may be times when you can't eliminate all the background, but that's easily fixed in post-production in programs such as Photoshop.

Notes

You will need a strong off-camera flash or a portable strobe.

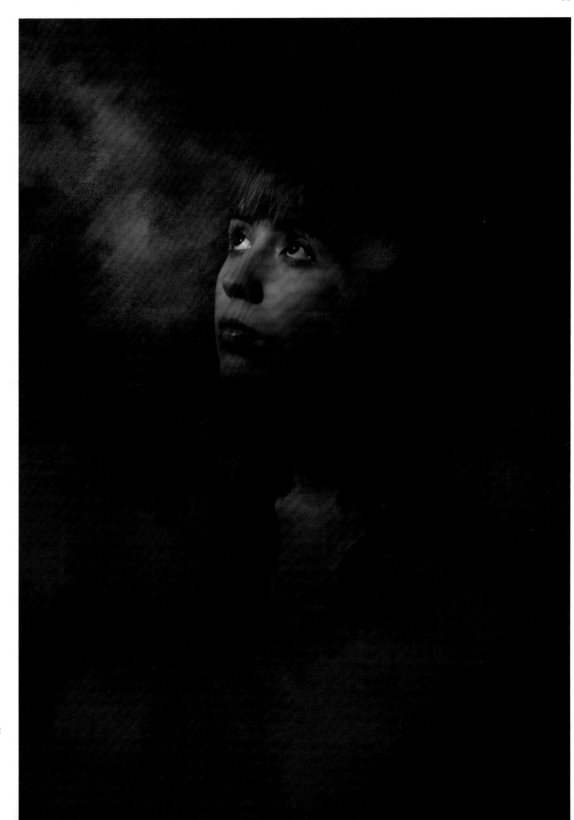

Right: Admittedly, the smoke isn't necessary, nor the tone, but it definitely gets the Rembrandt feel across more than mere lighting techniques.

Daylight Flash

Mixing ambient light with flash for unusual street photography.

Creating images with mixed lighting is a huge challenge, not least in the area of white balance. You will have to make a choice which of the light sources in your image to favour since artificial light and natural light rarely match. Thankfully, there are lots of ways to address a mixed-lighting scenario.

The first is to simply ignore the ambient light. If you're shooting a near subject with a camera flash, then the flash is likely to do all the work lighting your subject, and you can simply leave the background as it is. Depending on the time of day, the colour of the light in the background can create a strong urban look which nicely complements the effect of a close-camera flash. You'll want to dial the flash down a couple of stops so that it doesn't drown out the background altogether.

If you're aiming more at a composition more like the image opposite, then using a tool like the ExpoDisc is the quickest (and my preferred) way to get the right white balance dialled into the camera. The ExpoDisc turns your camera into an incident light meter of sorts. To use it, first of all, you want to be shooting with an off-camera flash or some sort of reflector – even a wall or ceiling is fine, you just don't want to be shooting with direct flash for this. Place the ExpoDisc over your lens and stand with your camera in the same position as your subject will be. Point the camera back to your shooting position (where you will be standing). Set the camera's white balance to Custom and then take a shot (you may need to put the camera into Manual focus).

Your camera will read the temperature of ambient light mixed with that of the flash and give you your Kelvin. If you are shooting over a long time, you will need to repeat this process throughout the day as the light temperature will change.

You still won't always be able to reconcile the colour of the light, even with tools and custom settings. If the temperature of the flash and ambient light are different enough from one another, you'll just have to choose one to favour, or go black and white like I did

with the image opposite that I took in Hastings-on-Hudson. The model's shirt is blue, but the white concrete at bottom left matches it because of the shade on the wall. Meanwhile, the white sign above is lit by the flash, so it's the correct white shade. Rather than choose an unsatisfactory in-between white balance or have one whole portion of the image with an undesirable colour cast, I just opted to convert to black and white!

Left, Top: Here, the on-camera flash is the main source of light, and it is cooler than the amber tone from the street lights around it, hence the orangey background. It actually creates quite a cool urban look.

Left: In these shots, we see the difference a flash can have outside. The first frame, with flash, looks a little warmer, and the background is darker. The natural light shot, the right choice in this scenario, is much more even in both exposure and white balance.

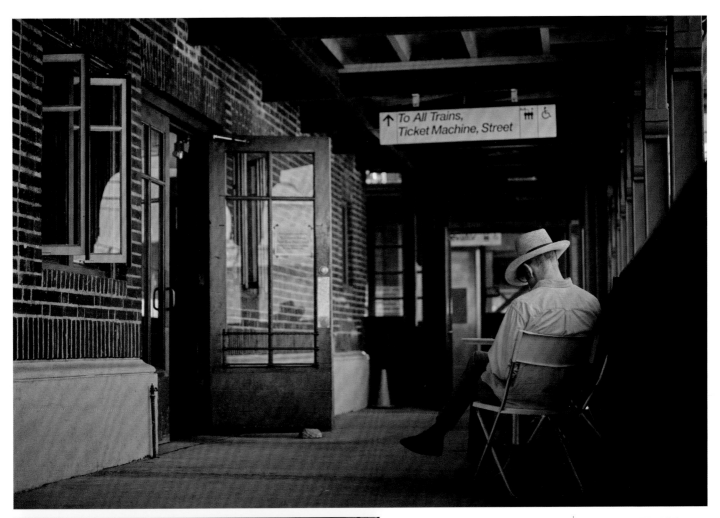

Left & Above: Mixed light captured with a reading from an ExpoDisc taken at Hastings-on-Hudson. The solution was ultimately to go monochrome.

Below: The ExpoDisc in use.

Personal Project

Impress and inspire with the things you do outside of work.

Like it or not, photography has changed. With a significant shop window provided by social media, photographers are no longer merely professionals offering a service, they're people too. Whether it feels like a good idea or not, many potential clients will want to feel some kind of connection to their photographer's style, and perhaps even their values and ideals beyond the job in question, if they can explore a personal portfolio as well as your professional work.

This isn't (quite) as silly as it sounds. Working with people can be very personal, so in general you're likely to have more success if you get on with each other. You will have a better time too, and since photographers can, generally, decline to work with some people, it's good to build a client base you like. A personal project on a particular subject, or location, as in these examples can give potential clients something to connect with.

It also might give the client some creative ideas of their own – for the current job or another – which they'll immediately connect with you. When a client books you, they will have a good grasp of the kind of things you can do beyond what they strictly need. If they like what they see, this is the chance to extend that relationship from one job into repeat contracts. If they don't, then they are unlikely to hold it against you because it's personal work.

Creating personal projects is likely to help you create better long-term relationships with clients. It's also an opportunity to practise something which, while it doesn't pay the bills directly, won't actually be a waste of your time.

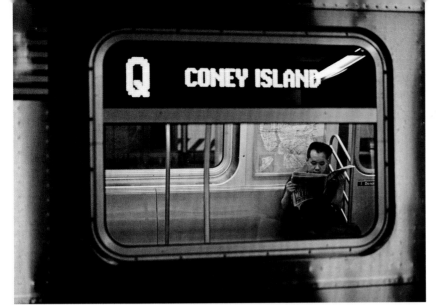

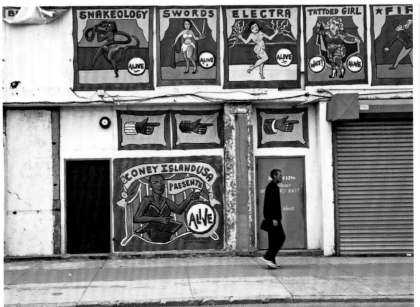

All: On their own, these images don't have a great deal of commercial purpose, but they represent what I like to shoot when I'm not 'at work'. I live near Coney Island, and photographing it helps build my connection with the place. Why wouldn't I share the photos?

Macro Portraits

If you think all portraits should be shot from distance, think again.

Many photographers enjoy shooting portraits with a macro lens, and there is no reason you shouldn't be one of them! There are some things to be mindful of – very common mistakes that can be easily rectified.

Using a macro lens presents a few challenges that a non-1:1-ratio lens does not: that's to do with the level of detail. Fixing a model or subject before you start is critical to success with shooting with a macro lens, so hire a makeup artist (MUA) where possible so you can save a huge amount of work in post-production. You are going to get a super-sharp and super-detailed picture, so you want as few flaws as possible, unless you like to spend hours in editing. This is especially true for headshots and partial headshots, where you're capturing just the face.

The other common mistake is where the shooter forgets to make micro adjustments to autofocus (AF) when shooting with a shallow depth of field. On many cameras, AF will only take you part way with a macro – you will need to nail the focus on the eye closest to the lens to the point that the veins in the eye are tack-sharp. This is where the viewer's eyes will be drawn to. If you're using focus stacking, then you will need to repeat the process with your shallow field shifted to the other eye too.

From a composition point of view, I prefer to turn the subject to the side, with maximum detail on the eye and nose on the same focal plane, with the subject sitting around 55° to the camera. Doing so will enable you to bring the hand in as a prop for the head if needed, or show some of the background.

As for lighting, a macro portrait is a real candidate for natural light; the catchlight from studio strobes will tend to look artificial and can be a distraction to the overall image when so much detail is being collected by the 1:1 ratio of the lens. This is by all means a personal preference and gives you something to play with. In some cases, you won't have the choice, but if you can work with a nice window, that is ideal.

What focal length to use? Any macro lens that is 90mm or longer will help you get a good bokeh effect, if that is what you are going for. And, anything in that range is a pretty natural focal length for portraits.

A few tips and tricks: I'd recommend using your lens' focus limiter if it has one (or simply focusing manually) to keep the lens from searching its entire range for focus. Also, use your camera's Zebra Pattern feature to alert you of overexposure. Along the same lines, focus peaking comes in handy here, so you can easily see on your screen what is in focus. And, finally, not all cameras have it, but Sony cameras have a lovely feature called Eye Focus, which will automatically focus on the subject's the pupil for you. It's unbelievably useful and great if you're recomposing your images all the time; it seems to border on precognition. If you are working with an unpredictable subject – children, for example – then it is miraculous.

Notes

Makeup is advisable, because macro lenses reveal a great level of detail.

Focus must be precise, as the depth of field will be very shallow.

Natural light is usually best for macro portraits.

Below: This shot captures the subject in a slightly wider scene. Here, I closed the aperture up slightly to get the eyes, nose and lips in the same focal plane. The image is still super-sharp and retains the benefits of the macro lens.

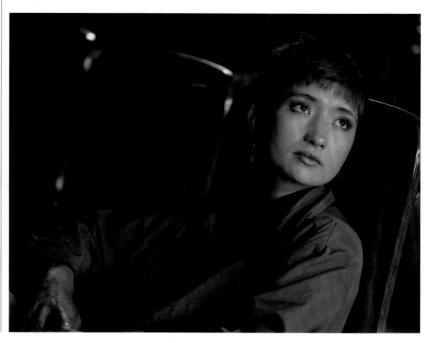

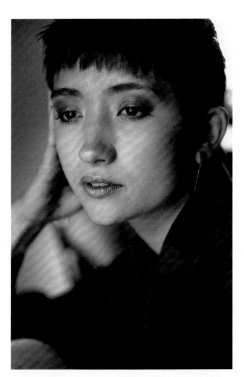

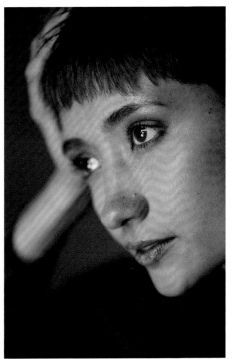

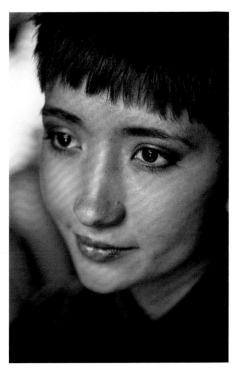

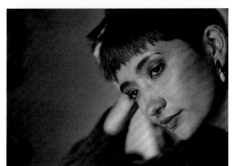

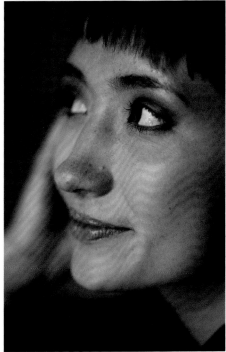

This Page: Macro lenses are great performers for headshots and close-up work. These portraits have all got the eye closest to the camera in focus and the subject is well framed in each.

Stock Up on People

Whenever the opportunity presents itself, you might be able to earn a few extra bucks.

It might not feel like the most glamorous area of photography, but it's one that can bring you a little income. If you've got a quiet moment, you can simply upload some images to a microstock agency like Adobe Stock and complete the metadata, then, if you're lucky, you might develop a small income stream. Not a massive one, to be sure, but one nonetheless.

The name microstock, in case you're unfamiliar with it, refers to the 'micropayments' approach: agencies pay a percentage of whatever they earn from the sale of each image, which varies according to the client's subscription to the site. The service will offer, say, 10 images a month for one fee, and 750 images a month for a higher fee that nevertheless costs less per image. Irritatingly, you'll earn less if a client on one of those higher-volume plans buys your work.

Still, if there is one thing that designers do not always have the time and resources to do, it's arrange a photoshoot with a model. Obviously, we would prefer the designers to hire us for a shoot, but if that's not going to happen, we can at least be the one who took the stock images that they end up buying.

Access to stock photography has become ever easier for designers, first with the arrival of the web but now with in-app integration. The Adobe Creative Cloud, which comes with the world's most popular design software (whether the users like it or not), places a little icon in the corner of the screen always inviting them to take a look at Adobe's library of stock images. If you use Photoshop, you're probably familiar with it, but you might be less aware that designers also use it, assuming that their application of choice is the now-dominant Adobe InDesign. Moreover, the app sends most new users some incentives to try out Adobe Stock.

Adobe Stock is just one option though, there are other agencies that definitely pay more per image. Traditional stock libraries pay better, but there are more hoops to go through to get on them.

In either case, you're going to need the model to sign a model release, and it's a good idea to explain to them what exactly you're going to do so they're not surprised if they suddenly appear on a poster in their dentist's office, for example. Very unlikely, but not impossible.

This doesn't mean carrying around a clipboard and an extensive legal document with you. You can download an app which the model can electronically sign there and then (very useful for street photography) right on your phone, ready to be uploaded with your images when you submit them to an agency. Buildings, too, may need releases. The Eiffel Tower is fine to shoot by day – it's old enough that the copyright has expired – but the lighting scheme that's turned on at night is not, so you need a release. Working through tiresome details such as these is best avoided, given the low potential earnings involved. Instead look for opportunities – ideally with models you've paid to work with on a job and who you get on with – to just grab a few more shots you can use for stock.

Notes

Always be mindful of where you can capture some shots for stock.

Get a model-release app like Easy Release.

Above: If you've got a model release with you, then it only takes a moment to turn a scene into something you can market as stock.

Left: Very early morning in Byron Bay. It was a day after huge storms, and the beach was pretty empty, making this shoot a great opportunity for a classic stock photo.

Above: You can be looking for stock opportunities all the time. Shoot some convenient stock images while you're out shooting literally anything else, and you'll be amazed at how quickly you build up inventory.

Follow the Flow

'Life moves pretty fast. If you don't stop and look around once in awhile, you could miss it.' ~Ferris Bueller

Events photography, like wedding photography, is a challenging task. It can feel thankless, and wrought with such a high level of risk of missing the key moments that you might forget that you have a higher purpose: to record (and enhance) the memory.

Traditional wedding photographers are inclined to sell 'packages' with a certain number of photos, and increase their fee depending on the hours spent at the event, with the goal of wrapping up after the ceremony. That's all well and good, but it feels somewhat staid; you're putting up an artificial wall between you and your client, when in reality, they want to capture the memories of the day in a way which will stand out above the swathe of camera phone shots they'll see minutes later on social media.

Packaging the day up so you miss all or most of the reception is not the way to take advantage of having rather better equipment than most of the attendees, and, if we're honest, the most memorable moments are often those at the reception and after-party. The other thing to remember is that memorable moments are happening the whole time for all the guests. Parties are not only about a single person, even one so dominant as the bride. While the bride herself will certainly want to be thoroughly documented, they won't want to miss out on glimpses of their guests' experiences either.

The long and the short of it is that you should do your level best to keep your eyes open to possibilities around the room. There are many you can anticipate – for example, speeches are almost inevitably going to get interesting reactions from friends and family, and those reactions do a great job of telling the story when viewed back. So, if you're shooting alone, grab a shot of each person to come up to the mic, then turn your lens to different guests, especially the wedding party and immediate family, but don't limit yourself. Everyone is there for good reason.

This (and the ceremony itself, of course) is a great time to take advantage of the silent shutter function of a mirrorless camera. A typical mirrorless camera like the Sony a7 III can capture 10 frames per second without an audible shutter click, so you can be sure of getting good images without disrupting important moments. Since there's a 4-second (40 frame) buffer on what Sony consider an entry-level body, you're virtually bound to get a good capture of the speaker before moving on to the crowd.

This is one of those occasions where technology can make a real difference. Eye-tracking autofocus, silent shutters and large, high-speed storage cards, plus ideally a second camera body with a different lens, are all going to make for a much easier time.

Notes

Remember to view the room for interesting moments.

You're competing with social media; so, get back, process, and post as soon as possible.

Consider working with an assistant to increase your chances of capturing everything.

Right & Far Right: Traditional formal poses are important, but later in the day, when people are more relaxed, you can get pictures that feel more inviting.

Left: A busy scene can work: here, the formal posing has started (the photographer is off to the left, surrounded by guests with phones), while the witnesses are signing the marriage certificate.

Left & Above: When someone – in this case the mother of the bride – gets up with the mic, there's sure to be a reaction shot. Insofar as you can, keep your eyes on everyone!

Single Strobe Work

Photographers are taught to control light, but that doesn't always require an intricate setup.

Making fine-art images with a single light can make for some great pictures, especially if you want to capture someone's form without it being too revealing. But key to this trick is controlling the light.

One way of doing so is using a flash modifier like a grid – or if you're using a strobe, a grid for a softbox or reflector. I prefer to use a 15 or 25° grid (the angle is the measurement of light spread). This is attached to a strobe reflector as I feel I can really direct the light this way as it's a bit easier to move around, especially in much smaller places. Elinchrom make a fantastic 25° grid, but there are a ton of options out there.

When shooting in low-key, you need to be sure that the only light visible will be the light that's hitting the subject. This style of shooting leaves something to the imagination, while highlighting form. The technique is similar to the 'Rembrandt' method we looked at on page 54, but here it is used to highlight parts of the body, rather than take a classic portrait.

Place the strobe head on a light stand around 1m (3 feet) higher than your subject, or more, depending on the effect you're going for. It should face directly down at them across their torso. Getting this right does take some practice, as the beam of light is going to be super-narrow. Leave the modelling light on and turn the lights off in the studio so you can see the effect before you start shooting. If you have access to LED continuous lighting, then these lights can be really advantageous in this scenario.

I shoot with an ISO of around 200 and a small aperture of around $f/11$, then I set the strobe to around 100w or harder, to taste. You may need to meter the light to work your settings out; but getting it right is important, because we want the light to fall away quickly so it doesn't illuminate the background. If you are seeing too much ambient light, then lower your ISO to 100 and then try and punch more light into the scene, but not a whole stop. Balance with shutter speed if need be. If you're using LEDs, a good test is to keep all the studio lights on and change your aperture in live view to see when your subject is almost gone from the frame.

Place your subject against a black background or well away from a background in a dark room. Take a test shot, and it should look like something in the examples on the page opposite.

You could also try to overpower the ambient light with a stronger strobe head, and throw the light directly at your subject. For the bottom image opposite, I used a red gel to give it a different mood, but the effect of light drop-off is exactly the same.

With each of these images, the light source is coming from the same place. The light is an Elinchrom D-Lite RX One, which is the cheapest in the Elinchrom range, so not too expensive. The images were edited with various amounts of washout to give them a classic look. But in all the images, the whole body is not totally visible. Rather, only some parts are, where I wanted to exaggerate the back, arms or chest. This kind of effect works best with fine-art images or anything where the human form is showcased.

Notes

Single strobe work is easy to do in a small space.

A grid is an easy way to control light spill.

Below: An Elinchrom D-Lite RX One without a modifier. The buttons on the back are used to adjust the light.

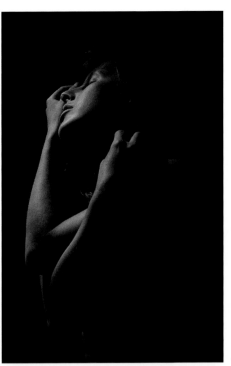

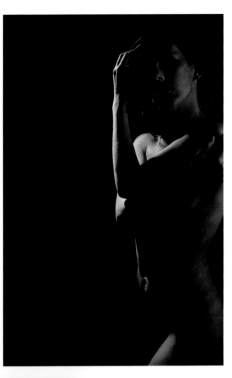

Above: I adjusted the curve of these images in post-production, eliminating true black and true white to give them a more washed-out feel.

Left: Placing red gel over the light is even more striking.

Light Painting

Invariably a striking way to produce an image, and one that technology keeps improving on.

Light painting is something often seen as a quick experiment in long exposures that does little more than impress our friends. These days, however, more sophisticated equipment allows you to do so much more. If you've never encountered the principle, painting with light is simply the act of making use of a long exposure to light certain areas of the frame. This is a look which requires a bit of effort and is always attention-grabbing.

The term 'light painting' is used in a broad sense to refer to moving a light source during a long exposure to create patterns or illuminate an otherwise dark area.

Shooting at night or in a darkened location, the camera needs to be set on a tripod and manually focused on the subject. A fairly narrow aperture will make the focus a little more forgiving and better facilitate a long exposure. Don't forget, as you dial in your focus, if it's too hard to see through the viewfinder, you can illuminate your subject (or the point where your subject will be), and use the live view zoom-in feature on your camera to see if it's focused before you take a shot. In the examples here, an ISO of 200 was used, but you might need to tweak this depending on the ambient light.

You can use any kind of light to provide the artificial light. One option would be to carry a flash gun, aim it at an area you'd like to highlight and hit the test button. Depending on your flash gun's cycle time, you can light up several parts of the frame in 30 seconds. The downside of this approach is that it might cause some unwanted shadows.

Generally, it's preferable to use a less powerful light like a torch. A torch can be used from behind the camera, or in frame if you keep moving, to illuminate a subject, as in the photo of the tree. Or, you can hold the torch so the bulb is directly visible to the camera to create a line-like effect. (When you enter the frame, if you don't want to be part of the image, you need to be dressed in a dark, non-reflective colour.)

Notes

Keep a stock of sparklers and don't forget a lighter.

Consider investing in a PixelWand, pixelstick or similar.

Don't fret if your camera doesn't have a Bulb mode: 30 seconds should be plenty of time!

Left, Top & Bottom: Two 30-second exposures of London's Olympic Park at night, one in which the photographer, dressed in dark clothing, wandered around in the frame waving a bicycle light at the tree on the left (top).

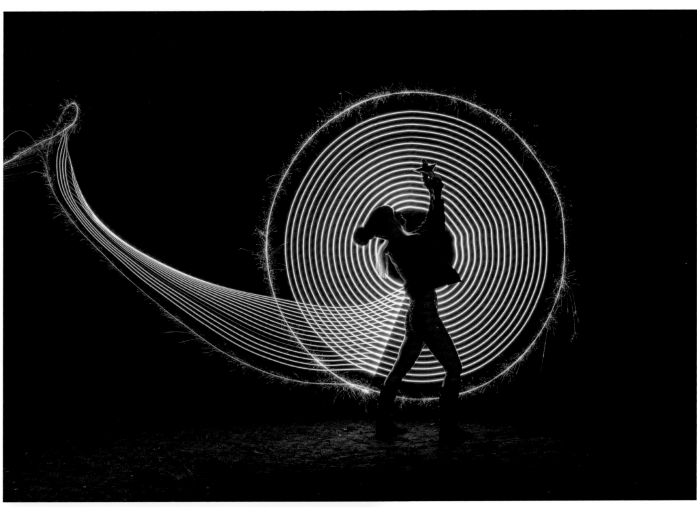

Above: Light painting with a model. I used a homemade LED stick and sparkler to create the pattern behind her, while she stood as still as she could.

Left: A close-up of a light painting can work well as a vibrant abstract image.

What makes light painting no longer just a fun experiment in a photography class but something you can make real use of in the professional environment is the prevalence of cheap LED lights which are bright enough to leave a trail in the frame, but not so much as to spill too much light onto their surroundings. They're also easy to switch on and off, which helps you in achieving a clear image. The best-known product in this space is the pixelstick, which can convert a BMP file (which you can export from Photoshop onto an SD card) into an image. It does this by flashing each line of the image, one after the other. If you move the bar relatively steadily, it can draw an image. This lets you harness an artsy effect for something a little more saleable, with all the benefits of a real optical effect (reflections, etc.) – much more effective than simply overlaying artwork in software.

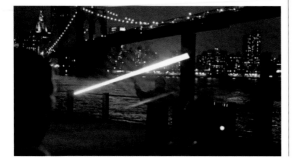

Above, Bottom: The pixelstick, held vertically and being moved horizontally, leaves the client's design and achieves a reflection which would have been virtually impossible in post-production.

Left: The pixelstick is an incredibly high-tech light bar.

Above, Top: The pixelstick can be used to paint colourful patterns into images.

Right: A simple menu on the pixelstick allows you to select a file, adjust the brightness and access all the other settings.

Left: The pixelstick was used here in Image mode to draw a pizza hovering in the air. You might choose to do this with a client's logo.

Below: Some of the gear for painting with light.

Above: The pixelstick is nearly 2m (6.5 feet) long, composed of LEDs which can be set to any colour. It can also be set so that, as it moves, the pixels change and, in effect, create an image line by line.

Light without Focus

You can create a festive look by capturing illuminations wholly in bokeh.

With a suitably fast lens (i.e., one that can be set to a wide aperture), you can create a bokeh effect which turns points of light into shapes, typically that of the lens aperture (but not exclusively, as we'll see on page 76). Usually bokeh is in the background of the photograph – a fast lens makes for a nice soft background – but you can also create a wholly out-of-focus image which makes the points of light look dreamy.

Illuminated decorations look great, but capturing them fully out of focus gives them a different aesthetic, one which actually works very well with quite a variety of festive copy, and as such makes for appealing stock photography. By removing the detail, you end up with an image that highlights the best feature, and any little imperfections in the arrangement of the lights or distractions blend away into nothing.

Another good surface to try discarding focus on is a shiny sea. If the waves and wind are such that glints of near-direct sunlight are being directed your way, a moderately long exposure on a tripod should serve to pick some of these out as bokeh effects without a dark background.

Notes

Use manual focus to stop the camera trying to fix the focus.

Aim for small bright lights.

These images make for useful stock.

Left, Top: This look is achieved with the ends of fibre-optic cables.

Left, Middle: This curve comes from lights wrapped around an ivy-like decoration.

Left, Bottom: This pattern of lights hung from a ceiling makes an interesting pattern with the converging verticals.

This Page: With all the coloured lights to capture, Christmas is a great time for bokeh-hunting. Diwali, Chinese New Year and other festivals and events where lights are a feature will also offer plenty of opportunities.

Projector Light

Video projectors can provide a cheap light with infinite possibilities.

There are so many expensive solutions on offer to provide photographic backgrounds, but there is one you might be able to find at the office or even at home. This lighting option offers a good deal of flexibility and can serve to change the foreground too, depending on your needs.

Video projectors provide rich, coloured light which might not immediately seem compatible with the photographer's studio – there is, after all, a pattern of pixels – but can be used creatively. For one thing, it provides the opportunity to paint virtually any design onto a surface (whether your model is part of that surface illuminated by the projector or not).

In a way it is a little like a slower, more controllable form of light painting. It gives you the opportunity to take your time to compose and experiment.

The key to using a projector is planning. You might not actually need to carry a computer to connect it, many modern projectors can play stills or video directly from an SD card or a phone, but in either case, you will need that material ready. So plan ahead with a selection of backgrounds. For an image like the arcade one illustrated, that was simple enough – just some screen captures.

Make sure you review your images and, if need be, work at a slower shutter speed to ensure that there is no conflict between the projector's refresh rate and the shutter speed. This shouldn't be a problem with modern digital projectors which don't actually use a shutter, but it depends on the technology. (It would be an absolute nightmare with a traditional film projector.)

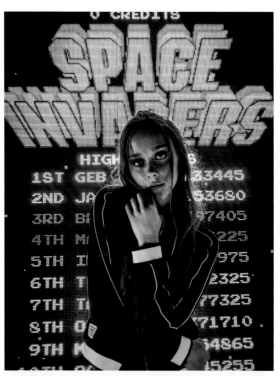

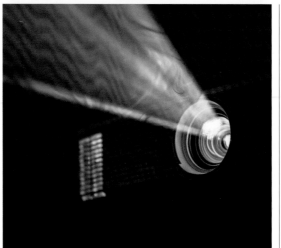

Notes

Video projectors have different resolutions, but not to worry. If you have a low-resolution projector, just soften the focus.

An older slide projector won't work the same way; be sure to use a digital projector.

Left, Top: A video projector can be used to give you a background if you can keep it out of the shot. Luckily, most projectors include 'keystone' adjustment tools so that you can put the projector above or below the frame yet present an undistorted image.

Left: A video projector. Notice that the beam travels up because of the keystoning feature – most modern projectors correct this effect.

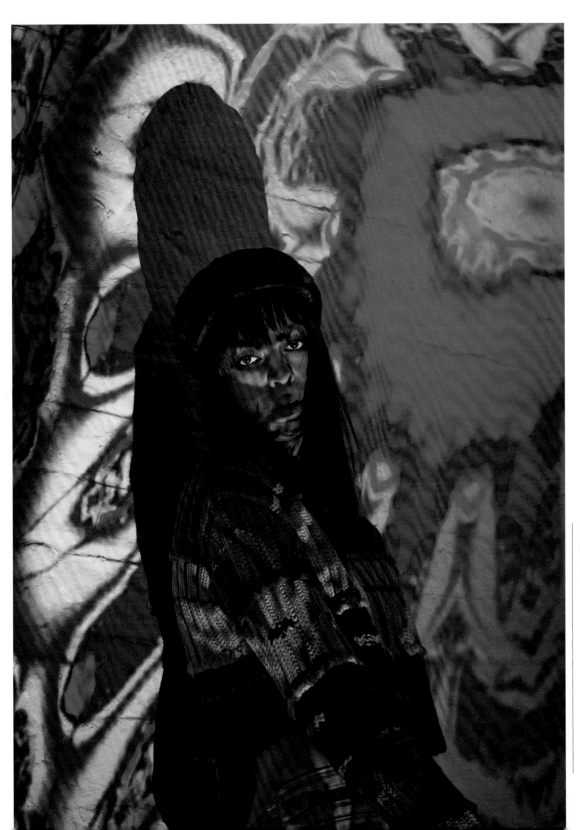

Left: A video projector can provide a much more dynamic light source than many bits of pro gear, with the intriguing addition of a hard, focusable edge.

Altered Bokeh

You can create near-unlimited number of potential artistic background modifications.

Soft bokeh is often a desirable feature in photos, taking the background detail away and encouraging the viewer to focus on the subject. If you look very closely at a soft-bokeh image and you know what you're looking for, you'll see that the soft points of light in the background take on the shape of the lens aperture. Closer inspection will reveal the number of leaves that the particular lens' aperture has.

You can actually control the shape of these light points. We can't change the shape of the aperture of course, but we can do the next best thing, which is to block the light at the front of the lens with a shape of our choice. The result is that shape appearing in the frame where spots of light would appear at a narrow aperture, or circles at a wide one.

There are a handful of filter kits available with different shapes to achieve just that, the Bokeh Masters Kit being the most widely available. Despite being mounted on the front of your lens, this filter doesn't affect your in-focus foreground subject, but only the soft-focus points of light in the background. It is recommended that you use the filters on prime lenses with $f/1.4$ or $f/1.8$ apertures for the best results, but you may also get good effects with a zoom lens of up to perhaps $f/4.5$.

Remember to experiment a little with this, and be sure you have enough points of light to make it worthwhile; the effect will be hardly noticeable on a daytime shot in most cases. You should also be mindful that you will be limiting the light into the camera and so you will be able to take a longer exposure or up the ISO (assuming you're already at the limits aperture-wise).

Notes

Adapter kits are relatively inexpensive.

For best results, use an $f/1.4$ or $f/1.8$ prime lens.

Above: A bokeh adapter fitted over the lens, ready to shoot.

Left, Top: Place the heart upside down (as you look at the lens) to get it to appear right way up in the image.

Left, Bottom: The Cablematic bokeh adapters are easy to fit and cheap to buy. If you're handy with a scalpel, you could try and create similar designs with some card. The Bokeh Masters Kit comes with eight blank filters that you can custom cut.

Above: Christmas lights scattered over an untidy personal workspace.

Left: Notice how the star changes shape near the edge of the wide-angle view.

Digital Multiple Exposure

Get a little bit graphical in your offering.

The modern professional photographer has a great deal of flexibility in how far down the processing line they go with their images. Photography certainly doesn't stop at the shutter release – you may choose to handle your Raw conversion, touching up and possibly more. Indeed, the market will likely make you.

In this example we definitely go a step further, perhaps into the realm of the graphic designer. Why would you want to do such a thing?

Apart from the often high salaries designers can command, there are two reasons for dipping a toe into the realm of the designer. The first is that it never hurts to try and think like your customers; put yourself in their shoes and try to picture a photograph as part of a page rather than a thing in and of itself, the end of the line. (That's why these examples here are shot on a white background.)

Second, of course, is stock. If you can provide an interesting graphical image which offers designers possibilities, then that will be the one that speed-workers choose from stock libraries. Cyan and red, by the way, are far from the only colours that this method works with, but the principle is the same, and they do hint nicely at a good-versus-evil vibe.

The Process

Shoot a portrait, lighting the background slightly more brightly so that it appears white. Do this with either a single image or, as in the examples, get a couple of shots which serve as counterparts; the model looking up and down at the same angle is a good example. Combine the images (or, if you just took one, duplicate the layer) in Photoshop as separate layers and use the Hue/Saturation tool – with the Colourize checkbox ticked – to set your chosen colour.

If you like, you might find it helpful to convert the image to black and white before you apply the Colourize tool, simply so you can use the Black and White tool to strengthen certain areas of the image in the conversion.

Finally, set the upper layer to Multiply, and reposition the upper layer however you choose. Where the images overlap, the Multiply blending mode will give you a striking darker shape.

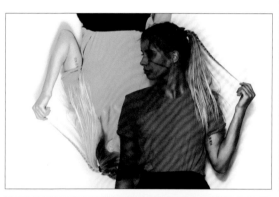

Left, Top: An example based on a single image duplicated and rotated.

Left: The only relevant layers in the image are the copies; the lower one has its blending mode set to Normal, so the Background layer is obscured. The top layer is set to Multiply and rotated using the Transform tool.

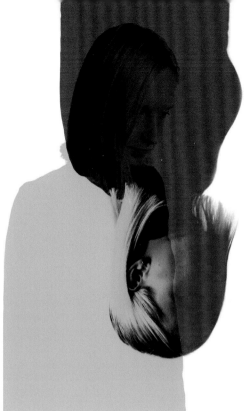

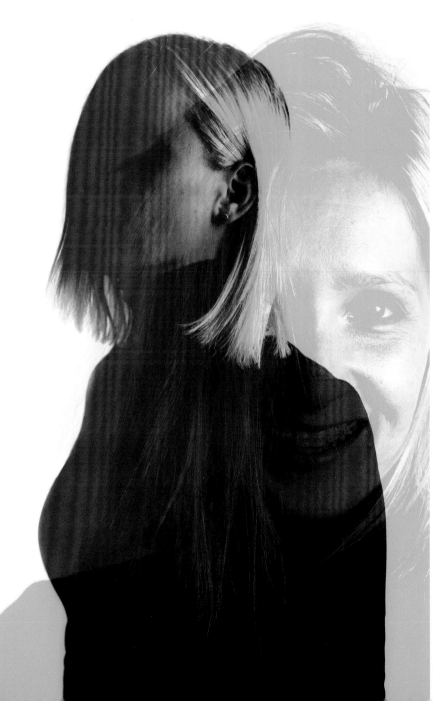

Above: These are separate images which were composed so that, when flipped, the heads would seem to be looking in the same direction.

Left: An entirely different image, compositionally speaking, despite using the same colours as the other examples on these pages. Here we see a seemingly faceless form in the red layer (achieved by lighting only the back of the model). This could have a lot of editorial uses.

Light without Spill, Wherever You Are

Add a grid to your flash to get sharper lighting.

A grid is a device use to create a narrow beam of light, effectively helping to control light spill. Of course these are commonplace in the studio, often used to modify light from studio strobes. It's a little more difficult to get the same effect on the road, however, with the more portable speedlight, or flash gun. The effect you're after, of course, is a controlled beam which has a hard edge to it.

When you're out in the field and you are indeed relying on the more simple, portable and modestly priced speedlights, you can now get a very similar effect with something you can throw in your backpack.

MagMod make a grid which can snap onto its magnetic mounting system which is held in place by a rubber neck that wraps around most flash units. This makes the grids so easy to place, remove, replace and stack. There are similar systems on the market, but I find this to be the fastest and simplest way of swapping out a light modifier.

In the images seen here, you can see the control of light in full effect. Even when using zoom on a flash, the MagGrid gives the same results each time. Foldout grids are also available for much larger lights should you be interested.

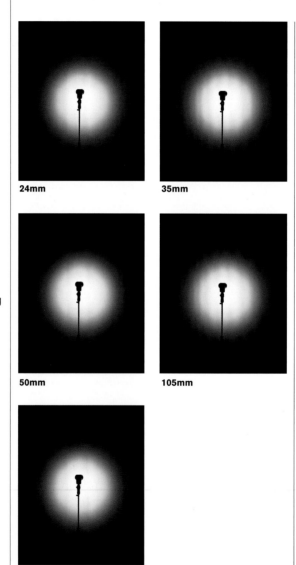

24mm

35mm

50mm

105mm

200mm

This Page: These examples show just how effective a grid can be on a zoom flash which would otherwise show very different dispersal patterns.

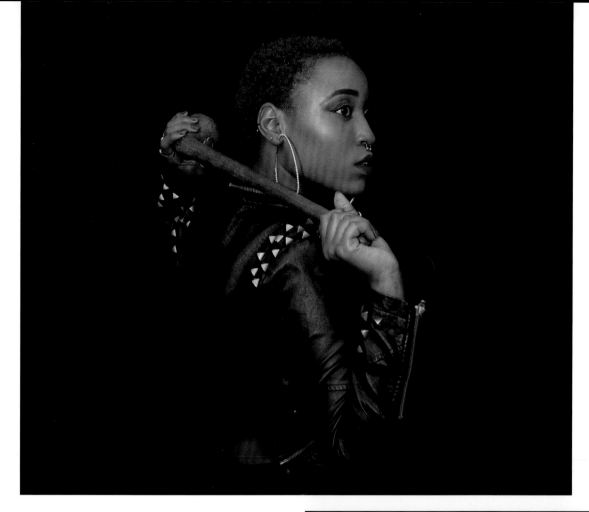

Above: Lit with two lights, the flash beam in this shot is used to gain the extra reflection on the model's face.

Right: A strongly focused beam of light from a flash gives you the possibility to light a model's face dramatically from a comfortable distance and still get fall-off above the shoulders. Keep the background a long way off and the light high enough, and you'll be sure to get a dark background.

Below: MagMod's MagGrid for flash.

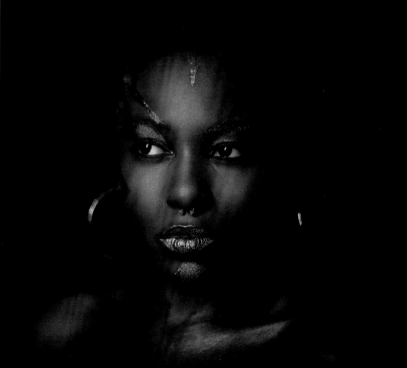

Get a Green Screen

Make composite images using chroma keying.

Green screen, or chroma keying, is a method of creating a background that can be easily removed on the fly or in post-production using software. Once it's removed, you can replace it with another image, placing the subject anywhere! (You can do the same trick with the majority of base colours, but chroma green is by far the easiest to deal with, especially as there are so many products on the market made for working with this specific hue.)

When it comes to lighting, you will need plenty of separation between your subject and the background to ensure no shadow is present and the colour is consistent across the frame. So, before you start, think about the lighting you will be using on your subject.

Also as important is getting the edge of your subject super-sharp; the sharper the defined edge, the easier it is to remove the background colour. This is especially the case with fine fabric, so work with a lens built for the task at hand, and be sure it's set to its sharpest aperture. (There's no place for a shallow depth of field here!) Avoid using rim lights where possible, as the edge can cause a few problems when using automated software to remove the background. If you are using Photoshop to remove the background manually, then you can work your way around that.

To light the background, use either a large softbox placed on each side of the background, or use some reflectors and a few strobes at each side to create an even light.

Use a light meter to check the light is even across the frame and the background, and make sure it's not overexposed. A great way to test this is to use a black marker pen and draw a square on a piece of white paper. Place the paper on the chroma key background, take a test shot and make sure you can see the box clearly in your exposure. I use this technique to make sure I'm close to where I need to be from an exposed-background point of view, even after I have light metered.

Again, remember you are shooting with the sweet spot of your lens, so $f/8$ to $f/13$ will be the range you need to be looking at from a light/power perspective. Also keep in mind you will need a pretty fast shutter speed to get that crisp edge. Turn off your Auto White Balance (AWB) along with any HDR assist feature that your camera might have. Have your ISO as low as it will go at the required settings and use the power available to you in your strobe head or flash.

Now for lighting your subject: before you start throwing light on them, think about the background or environment you will be placing them in. Will it be natural light? Which way is the light in the scene going to be coming from? What time of day is it in your background scene? How long are the shadows? Working all this out means your image will have a more natural look to it rather than looking like it was shot in a studio. There are tons of great examples of where this has been ignored and the resulting image looks a little weird.

In the examples here, I used one large key light and a small fill, positioned to leave a shadow on one side of the subject's face. I placed two 60 x 60-cm (24 x 24-in) softboxes to light the background. Sometimes the exposure isn't perfect at the very top of the background, but that's okay. We only really need to be able to remove the green around the subject's edge, as the rest can be brushed out easily, and there is a level of tolerance in automated software that allows for this. On the whole, however, the more even the green is, the less post-production you will need. To get that all-important sharpness right, it's highly recommended to tether your camera to Capture One or similar so you can 'pixel peep'. Once you get everything right, you'll be able to remove the background in post-production with ease.

Notes

Green is not the only choice for backgrounds, but it does have technical advantages.

Use softboxes to get an even light on the background.

Light your subject without creating a shadow.

Left, Top: An evenly lit screen is the key to easy selection (though you'd be surprised how well video software like Final Cut Pro can handle imperfect lighting, while Photoshop struggles).

Left, Bottom: Our chosen image with the background selected and masked. Try the Quick Selection tool then Inverse or, failing that, the Magic Wand.

Above: Having masked out the original, you can drop in any background. Ideally, use a shot at a similar focal length of a more distant subject and add a little blur to give the impression of depth of field.

Lip Match

By linking the lip shade with the background, you can achieve a striking look.

When we look at a photograph, we are naturally drawn to any faces in it. It's a biological instinct programmed deep into our evolutionary psychology. As a result, you might find that the attention of the viewer is drawn more directly to the model, and less towards the whole of the photograph than you might like.

Psychology also tells us that the lips draw a great deal of attention, so we might be able to make the viewer see the image more holistically if we connect the colour of the lips with a colour in the image. It's worth noting that this effect, in broad terms, will have more effect on men than women, at least if an eye-tracking study by the University of Southern California can be relied upon. Researches found that men were more likely to look at lips, while women were more likely to look at the whole scene and the subject's body. Make of that what you will.

The striking effect cannot be denied though, because the part of us that looks for patterns is seeing the matching colours, while the part of us that looks to catalogue and identify faces is looking at the facial features. By hijacking this process and drawing it in two different directions, we force the viewer to linger a moment longer on the photograph than they would if the lips didn't match the background. Any momentary pause is enough to please a commercial client, whether they're looking to boost the click-throughs or grab eyes scanning along a shelf.

From a photographic perspective, there are two ways to achieve this. The preferable one is to work with a good makeup artist who can recreate the colour you choose. It's best to give them some advance notice if it is a shade they're unlikely to carry.

The alternative is to shoot with a broadly similar shade on the luminescence scale (i.e., dark lipstick for a dark colour, light lipstick for a brighter colour), then select the lips in post-production and mask them, before applying a Hue/Saturation > Colourize effect. It's harder to achieve a natural look with this method, even

if it should be a more technically perfect match, but the advantage is that you can choose to try it retrospectively if you like. Do you have a picture you like in your stock collection? Why not apply the effect a few times for different shades and add it to the collection with the colour named in the metadata?

Notes

Anything unusual grips the viewer momentarily longer.

Work with a makeup artist if possible, and let them know in advance what colour you're looking to match.

Above Left: Not exactly the same colour, but the lip shade and the paper are at least on the same tonal range.

Above: A very pure example of the effect, it's attention-grabbing and it takes a little longer for the viewer's gaze to settle on the model's eye.

Left: Here, although the window is somewhat distracting, the model is linked to the image's background by her lips.

Vortograph

It's all done with mirrors.

A vortograph is an abstract kaleidoscopic photograph taken by shooting an object or scene through a triangular tunnel of three pieces of glass or mirror. Its inventor, the abstract photography innovator Alvin Langdon Coburn, did most of his work in the early 20th century, developing his vortographic technique in 1916 and 1917. The aesthetic can still grab a lot of attention today, however. So much so, in fact, that architects have got in on the act, as the Tokyo Plaza shot below reveals.

If you never played with one as a kid, a kaleidoscope is a tube that you look into from one end and inside are reflective surfaces which can be rotated to create strange optical effects. For making a vortograph, you probably won't have much luck shooting directly through an actual kaleidoscope, but you can make something that mimics one in a scale that you can shoot through with your camera.

You're looking to acquire three long (15cm/6in), narrow (around 2.5cm/1in) strips of glass or mirror. Then you'll tape or glue them together in a triangular tunnel shape and simply shoot your images through the tunnel. If you use a reasonably wide aperture without going over the top – something like f/4 – you should find you're able to get tack-sharp focus on the subject and so-near-to-perfect-you-wouldn't-know focus on the direct reflections in the tube. The end of the glass closest to the camera, however, will be so near the sensor that things will be comfortably out of focus, creating a gentle blur.

Experiment with different positions; you can get a model seeming to look two ways (as in the example above). You can also experiment with how near the lens is to the kaleidoscopic tube. If the tube moves a little closer to the subject and farther from the lens, you'll see reflection from the opposing mirrors within the tube, and the direct view of your subject will take a smaller proportion of the whole image.

Notes

Always look for opportunities to create stock.

Get a model release app like Easy Release.

Left, Top: A simple shoot of a model in a field is given a different look through a triangular prism.

Left, Bottom: Vorticism applied to architecture. Travelling the Tokyo Plaza escalators is not unlike being in a vortograph.

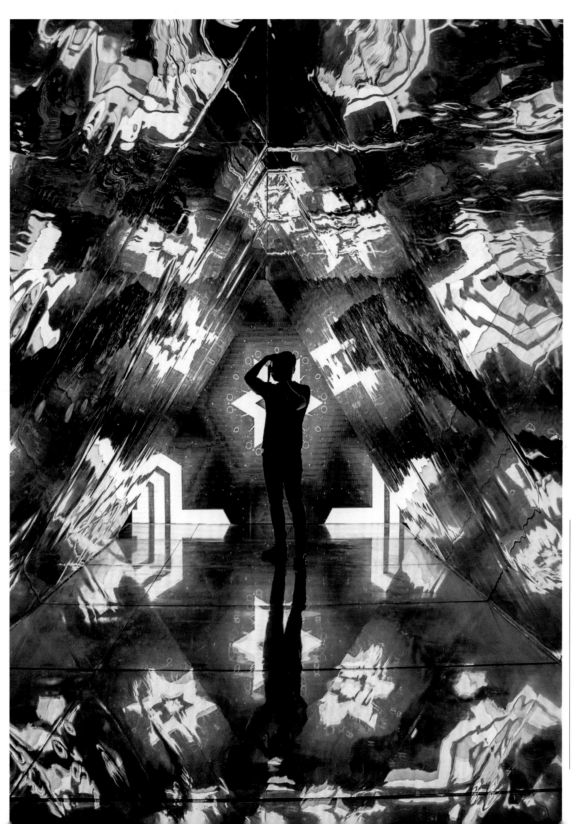

Above: For a different look, kaleidoscope sunglasses are easily found online. You could even experiment with shooting through the lenses.

Left: A rather bigger version of our glass prism attracts a photographer's attention.

3

**Interiors &
Real Estate**

Creating a Narrative

Big money can hinge on interiors if you work in real estate.

Each home is decorated in such a way that it normally reveals something of the personality of its owner as well as the character of the house. For real-estate interior photography, find that character and capture it.

Looking for these clues can really help draw a narrative that your clients will love. For example, a country house may have original doors and door knobs that normally would be overlooked, but you can try to shoot them in a way that really highlights them. You could do this, perhaps, by photographing a room and then turning around and shooting the way you just came in, featuring the door and fixture while helping the viewer to picture themselves in the house. A feature fireplace is always a great item to draw out, and a nice additional touch would be to capture the logs on the porch too. Doing all of this really creates a sense of a narrative for the viewer and its a simple thing to do, but it's very often overlooked in favour of HDR shots.

In these images of a property I shot in New York, the owner was heavily involved with film, so many of the features from light fittings to wall decals had something to do with the movie industry. Had I missed them, it would have been 'just another apartment', which isn't as much fun to look at for a potential buyer.

You might think that such details shouldn't matter to a buyer, but in fact it's known that seeing a home decorated helps draw people in. The furnishings help people to start imagining themselves in the home, which makes them a step closer to buying before they've even gone to look at the place.

Renting or purchasing furnished flats with shared amenities like a spa, gym, patio or pool is increasingly common these days. This offers a whole ready-made lifestyle, often expressed through these communal facilities. Whatever amenities are exclusive to the tenants or owners can be the factors that make the sale, so remember to capture them too.

Above: The light fixtures in the kitchen and dining area, along with the art reflected in the hallway mirror, show some clever design ideas to inspire potential buyers.

Left & Below: Be sure to ask about any shared amenities in an apartment building or complex, and be sure to shoot them.

Above: It might not seem stunning, but the shot above goes a long way to selling a home; it shows the quality and newness of the all-important home hub that is the kitchen, but immediately draws the attention to the more comfortable world beyond.

Left & Far Left: Furnishings and design elements, if they are tasteful, can influence potential buyers, helping them to picture the lifestyle they might aspire to by living there.

Flat Facades

Facade shots can really make or break someone's interest in a home.

In real estate photography, an external image is often the first thing a buyer will see. Realtors want to see clicks, and choosing something interesting (but still reasonably conservative) can really help. A straight-on shot brings the opportunity of using foreground to try and tell a story of the exterior, but you have many options to consider.

A close-up detail of a doorway can work well, especially if the door can be opened slightly or there is a light that can throw some illumination onto a darkened doorway. Obviously this depends on the doorway being attractive in the first place, but items such as doorbells, historic plaques, archways, door knockers, house numbers and steps can all suggest the character of the property beyond the doorway.

The doorway is only part of the story. Choosing a portion of the house exterior to include in the straight-on shot can be just as challenging. Obviously, cars, poor backgrounds and the like can be hard to crop or change in post-production, so try and eliminate as much as you can before you shoot. One great way to hide poor backgrounds is to include some hedge or bush that could be used to clone over the parts you want to hide. The Rule of Thirds is one you really need to stick to when doing straight-on shots, especially if there is a feature you need to draw the viewer's attention to.

The sun's position is important too, and you may be stuck with it in your shot. If you're going to use HDR on a bright, sunny day, then really close up the aperture to $f/13$ and beyond. This way, the sky's highlights are drawn out, and any direct sun appears as a burst.

Lenses to Use

For exterior shots, I use one of three lenses: the Tamron SP 15–30mm, a 30mm prime or a 'normal' (45/50/55mm) lens of some kind. Keeping the images within that range is closer to the natural eye-field width, which makes for a natural, pleasing perspective.

You will at times be forced to shoot with a super-wide angle to capture everything you need in the shot. This brings a couple of problems, including a skewed perspective (architectural distortion), and depending upon the lens, varying amounts of barrel distortion. To deal with the former, shooting with extra space around the property means you can fix the keystone in post-production. (The added distance will minimize distortion a bit too.) 'Fixing the keystone' means straightening out the parallel lines that seem to lean towards each other in an image, a problem typically associated with shooting the outside of a building (especially with a wide-angle lens).

You can use Lens Correction in Photoshop to repair barrel distortion, which can make lines, especially around the edges of the photo, appear curved when they are in reality straight. Believe it or not, if you don't perform these adjustments, some potential homebuyers will think the building is crooked.

For anything that really doesn't need a wide view – those detail shots of doorways, arches, garden features and so on – I use a 30mm or a 55mm prime lens. Using a prime means less distortion at those focal lengths, and generally these lenses come with very wide apertures, bringing with them more opportunities for creative images. Just because you're shooting for a client doesn't mean you can't let the creative juices flow a bit! When looking for beauty shots, I keep an eye out for features with a small bit of shadow to add depth.

This Page: The American South offers such a wealth of character that any creative real-estate photographer located here should be in their element. Doorways, garden gates and framing opportunities abound.

How to Be a Vampire

Letting mirrors be a problem can curtail your interior shots. There are solutions.

The first step to handling mirrors in a scene is to compose your image so that extracting you and your equipment isn't going to be too much of a headache should you end up with no choice but to have a little bit of gear in the shot. It might seem easier to avoid mirrors altogether, but there are clear advantages to using a mirror in some of your interiors. For one thing, they can make a room seem bigger. (That, after all, is often why interior decorators place them to begin with.) Secondly, you can use them as a framing device, as in the example with the beds in the mirror and the decoration in the foreground; it helps people see an environment as a potential home.

A partial solution is to make sure that you yourself get out of the way so you're only dealing with the camera and the tripod. Simply using the camera's timer will allow you to get out of the shot.

It's also a really good idea to think in terms of the editing experience. Some surfaces are a lot easier to handle with the Clone Stamp tool, Healing Brush tool and Patch tools than others, so those are the ones you want your gear to be obscuring (if any). The easiest-to-handle surface is a painted wall. Some texture is all right, and in theory, repeating patterns like tiles should work too; but it's by no means guaranteed, especially when this surface is not flat-on to the lens, so this is something it's better to avoid.

On the subject of thinking in terms of the editing experience, if you're working with the camera locked on a tripod, the other option you have available is to compose a shot in which your camera is out of shot but you/the light can be in shot, then take that. Afterward, reposition yourself and the light into the shot (but not obscuring the mirror) so you can point the light in the direction of the reflected area. This is great for shooting bathrooms from the doorway where the mirror's reflection looks out of the doorway.

A useful tool for this is an iPad with an app that lets you look through the camera's viewfinder remotely so that you can be sure you're not obscuring the mirror when you capture your second shot. You, holding and directing the light, are no problem at all since the only part of the shot that matters is the reflected part.

Then, back in Lightroom, select both shots and perform lens distortion corrections and so on, before exporting the images to Photoshop as layers. So long as the lens correction was performed, it should be a matter of four clicks with the Polygonal Selection tool, then a moment with the brush, to mask out the mirror area.

Have a circular polarizer on hand; you can use this to provide you with the non-reflective surface which you can emphasize in post-production should you choose.

Reflections pose a secondary problem, especially for the flash shots: light can be redirected into less than desirable spots. You might find it worth bouncing the light from a few different directions, and it may turn out that a direct flash image isn't worth the time at all.

Notes

Avoid appearing in mirrors and you can use them to make the room look bigger.

Direct your camera at mirrors at an angle.

If your tripod must appear in the mirror, make sure the background behind it is easy to clone.

Left: I've avoided the mirror, but the tripod shows up in the flush fitting. This is the kind of thing to keep an eye out for on shoots, as it can save valuable time later!

Left: In this case, shooting the mirror from an angle provided an opportunity to creatively show the most important parts of the room in one image.

Left: Although it may appear uncanny to an experienced photographer, most viewers won't even notice that there should be a reflection of a camera in the mirror. There was, of course, but I was able to easily clone it out in post-production.

Shoot Flambient

Mix flash and ambient lighting, and perhaps a splash of HDR.

'Flambient' is a term used for mixing flash with ambient light to create a kind of HDR-plus effect, which is pretty much how I shoot 90 percent of the time for things like real estate. You will see this term thrown around a lot in the real-estate photography biz, so it's one worth picking up if you plan to add interiors to your portfolio.

Shooting in HDR mode is a great way of ensuring that you have all the dynamic range you need to lift areas of the image from the shadows and present all the detail that people need to see, but HDR doesn't, on its own, handle lighting. When you're shooting a room for a client, you'll be expected to overcome problems with light. This can be a challenge, thanks in part to the variety of shades of 'white' that come from the different kinds of light in the modern home (incandescent, fluorescent, LED, halogen, etc.). They don't look very different to the eye, which is used to compensating for them, but the Auto White Balance (AWB) on your camera will show the difference between these lights and the ambient lighting clearly.

To make things easy for yourself, check with the homeowner if they have smart bulbs which you can adjust to a uniform tone. These bulbs are still not common, but if the home does have them, then your job will be that much easier. For every angle that you shoot (every finished shot), you will need to capture seven exposures; five at different exposure values which will be merged as HDR, and two more flash shots. Use your preferred HDR tool to process the image as close to your taste as is possible from the ambient-only shots.

Now start making things flambient by merging your ambient images in the HDR tool so that you're left with one frame, and then export the images to Photoshop as layers (you can do this directly from Lightroom). Ensure that the HDR image – the ambient one – is the top layer.

Although you shouldn't need to, things do move a little, so you can align your Photoshop layers using Edit > Auto Align Layers (select all your layers first).

Select the top layer (the HDR image) and pop over to the Channels window. There Cmd/Ctrl-click on it, and you'll see that a selection is made of the most luminous pieces of the image. Click back to the Layers panel and, with the HDR layer still selected, click the circle-in-a-rectangle icon at the bottom of the window to create a mask. Apply the Luminosity blending mode to the layer, too. (You might want to create this as an Action, as you'll be doing it a lot.) To finish up, paint any areas in or out of the mask to complete the effect to your taste.

Alternative Balances
Depending on how great a dynamic range I perceive in the scene, I either shoot:

1) Five shots at 1.3EV, including one at 0EV; plus take one bounce and one direct flash at 0EV.
2) Five shots at 1EV, including one at 0EV; plus take one bounce and one direct flash at 0EV.
3) +/- three shots at 1EV ambient only (plus one at 0EV), +/- three shots at 1EV with bounce flash, and +/- three shots at 1EV with direct flash.

Notes

You will need a tripod.

Shoot a group of HDR without flash.

Shoot flash directly and bounce it.

Merge using Luminosity.

Left: The flambient image layers in Photoshop. You are able to blend the flash layers as you choose.

Left, Top: The finished scene created from the images below. Notice how the flash-lit kitchen retains much of the sharpness associated with this kind of light, while areas completely unlit by the flash (the far room) are light and welcoming.

 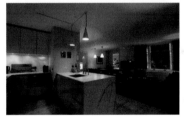

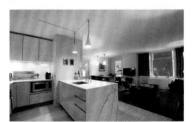

Left, Middle: The five images used for the HDR composite.

Left, Bottom: The two flash shots, taken at the same EV as the middle HDR shot, using both direct and bounce flash.

Outside In

A room with a view.

It might seem very unnatural to the one-frame photographer, but in the world we live in, real-estate clients don't really see photographs as an artistic achievement; they want to show off as much as possible about the room – and its view – in a single scene. HDR techniques have been a godsend, but they don't solve everything.

Big windows let in a lot of light, and are reflective, which means that it's difficult to shoot the room and control the lighting. You don't want to see flash bounced in the glass if you can help it. On the other hand, you do want to show what the prospective owner can see through the big window – if it is big, the view is likely a selling point in and of itself.

There are a couple of options; one is to shoot the view as single frame, then shoot the room as you would otherwise, and blend the two by masking out the windows in Photoshop. It's not as time-consuming as you might imagine because – if you use your Perspective Correction tool first – you can usually select the windows with a few clicks of the Polygonal Selection tool. This gives you the option of shooting your outdoor view with a filter or any other tool you might use to enhance the sky without fear of affecting the interior. Just don't ham it up too much – buyers are increasingly photography-literate!

The other option is to shoot an HDR view of the scene and a flash shot, as you might with the flambient concept on the previous pages, but to more aggressively mask the windows with the brush in the masking process. Given that you're going to be capturing an image with a mix of tonal range, the slightly mid-tone bias of Photoshop's standard HDR settings can prove something of a boon, making the overall shot look more natural.

Another thing that we need to decide how to handle these days is giant TV screens. A feature of most homes, a big black rectangle isn't the most beautiful thing you can imagine (and buyers don't really

like to see themselves as couch-potatoes). Ideally, you can replace them with something appealing, but they're often bolted onto the wall. My preferred solution is to place a nice stock still that feels a little artistic onto the screen using Photoshop. A TV screen image is 1,920 x 1,080 pixels (or double that in both directions for 4K). It's easy to position an image over the TV screen using the Transform tool, but only do so if you're working on a perspective-corrected image, or the pure rectangle of the image, even once distorted, will never fit.

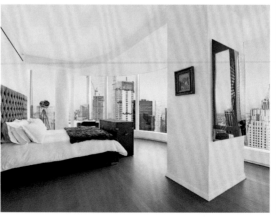

Notes

Keep some spare stills to 'fill in' TVs.

Shoot an exposure to fill in the window view.

Left, Top & Bottom: This pair of images show virtually the same view, but the angle changes subtly and so does the view. It's always worth moving around to give yourself different options to work with.

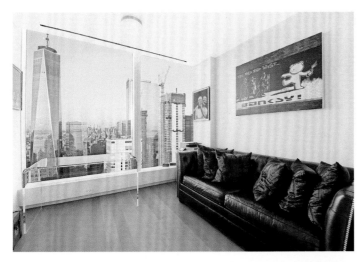 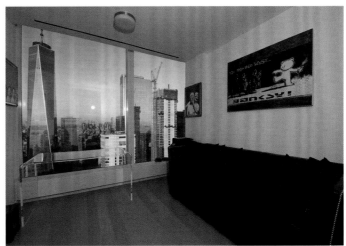

Above Right: A simple flash image would have been the traditional solution to balance indoor and outdoor light, but reflections would be a problem.

Above Left: Here, the flash-lit interior is softened without losing detail and, by painting the flash out of the mask altogether, the window view is the slightly softened natural look we've come to expect from HDR, bringing the outside in.

Middle Left, All: Some of the selection of HDR images taken for the above view.

Far Left: A television in shot can be a blot on an otherwise attractive apartment.

Left: An additional alternative: this is the TV's view of the apartment – rather nicer!

Pop-Pop

Keep the benefits of flash, but eliminate the shadows.

As an experienced interior photographer, I know never to miss out on capturing HDR images, but they don't always solve all of the problems I have capturing a clean-looking shot. Flash, though, has a tendency to cast shadows, so what's the solution? One option, of course, is a huge bag of lights carefully positioned around the scene, yet somehow not appearing in the shot, but that's hardly a practical one, especially for a busy professional trying to make a profit.

A much more palatable option in terms of work-life balance and gear-lifting balance is to spend a few extra moments merging images caught from two different pops of the flash.

At the zero EV point of however many exposures you choose to take for flambient purposes, there are two flash shots, as laid out on page 96. Move the light from one side of the lens to the other so that the shadow will move around objects in the room. The goal is to spread light around corners so that we can eliminate the shadows in post easily, as we will have captured what's behind the shadow.

Blending is more difficult as we have to remove two shadows now, however it's less time-consuming because we can now merge two flash images before we do the final blend.

Begin by creating an image composed of both the originals in Photoshop with the upper layer set to Lighten. This will eliminate shadows but perhaps introduce some unwanted reflections. If needed, group those layers and duplicate the group, but adjust the new group so that it is set to Darken. Give the group a layer mask that eliminates everything (is black), then paint over any highlights with white in the mask so that the finished image eliminates tricky shadows but doesn't show any flash reflections.

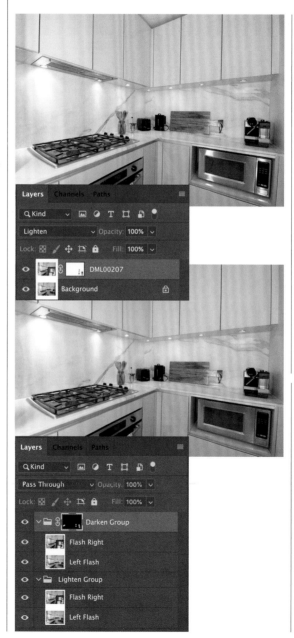

Notes

Eliminate shadows with multiple flash shots.

Create a duplicate 'Darken' layer to eliminate unwanted reflections.

Left, Top: The quick and dirty way to pull this off is to simply use the two frames as layers in Photoshop with one set to Lighten. You can then paint out a few areas to mask out the extra highlights.

Left, Bottom: The more sophisticated way is to take the above Lightened pairing and place them in a group, then duplicate it but switch the upper layer to Darken, then create a layer mask. Use this to paint in any areas you'd like to darken, like the microwave.

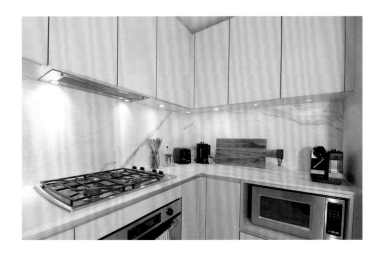

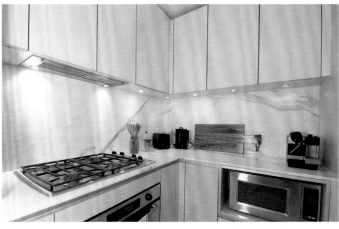

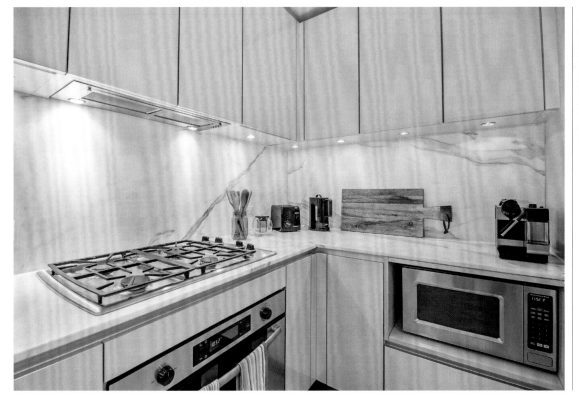

Above Left & Right: The original kitchen images shot with the flash moved from camera right to camera left.

Left: The finished blend. Notice how the shadows cast by the right-hand wall and the left-hand coffee maker are eliminated, and it was easy to remove glare from the microwave.

360° Shots

Ever more called for, this is something a good tripod can achieve much more effectively than cheap handheld cameras.

There are many products on the market that can create 360° images, but none of them achieve the quality of a DSLR. Of course, 360°-specialist cameras can do a fine job, but not in the same way. Unless you have a vast budget, the cameras typically stitch two or perhaps more 'fisheye' images together and are not unlike GoPros. They're marketed with promising-sounding numbers of megapixels, but this number is for the whole scene recorded. Given that people will only be viewing part of the full image at once, the quality of such cameras is simply not of a standard that feels professional.

If you're shooting for real estate, or another situation where you're only trying to capture a static subject, you can, with a little time and effort, create a much better-quality image which, when fed into any kind of 3D viewer, will truly wow. Of course this kind of thing isn't free; you'll need a good lens and a particular kind of tripod head. Before you start shooting, you have to understand how all the stitching happens in post.

Your goal is to capture images, much the same way you would for a software-stitched panorama, with enough overlap for the software to identify features and merge them. Without great reference points, you may have a poor or torn image, and you may have to manually stitch the images together in post-production to get a decent composite.

Selecting a Lens
There are a lot of lenses which can create 360° images, and its down to preference. Again, it all depends on your budget and the quality you are aiming for. There are a few rules of thumb. You will be shooting in Manual, with an aperture of around $f/11$. Fast glass is always good to have, but it's not essential. Wide is good though; the wider the lens, the fewer images you'll need to shoot. An 8mm lens will only need four or five images from left to right to make a panorama, while a 10–12mm lens may need five or six images. The Sigma 8mm $f/3.5$ EX DG Circular Fisheye has been a popular choice for

360° content creators for years, but another option is the Rokinon 12mm $f/2.8$ Fisheye. In this example, I used that lens on a Sony mirrorless camera.

Tripods & Heads
For 360° work, a good, heavy tripod works best – something a bit heavier-duty than the one you would use for travel. You will be rotating the head to move the camera between frames, and you don't want to risk messing up by moving the tripod. Slik make some excellent tripods. Be mindful that indoors you will set the height of the tripod around 1.5m (5 feet), any lower will feel strange for the viewer (they'd feel short). This is a little higher than for regular internal shots. If you're shooting 360° outside, then you can go higher.

As for a panoramic head, there are a ton of them to choose from. If you're looking for one for the Sigma lens I mentioned earlier, there are special heads designed specifically for that lens, which means you don't have to worry about the nodal point or point of parallax (more on this shortly). Nodal Ninja make fantastic panoramic heads for all kinds of cameras; if you're using mirrorless, then you can choose any of the smaller heads.

Using a Panoramic Head
Once you've got all the gear, you need to set it up. The base of the panoramic head will have small indents which you can set to take four, five or six shots in a 360° motion. If you have the Sigma, you can set this to four, or a 90° difference between shots (360° / 4 = 90°). For the Rokinon lens, you set it to six, or 60°.

Setting Your Nodal Point
The point of parallax or nodal point is the point where the light enters the lens over the rotational part of the tripod head. This means that if you move the lens from position one to position two, items in the frame will remain in the same place in relation to one another and not shift. This is important for getting a proper stitch.

You will need a wide-angle lens.

You will need a panoramic head and a sturdy tripod.

You will need dedicated software like 3D Vista.

Opposite Top: This stitched-together panorama is made up of six images.

Opposite Bottom: When the image is fed into a social media account like Facebook, it is automatically recognized as a 360° image, and you're asked to choose an initial position. When viewers click on it, they will be able to drag the image to see in any direction.

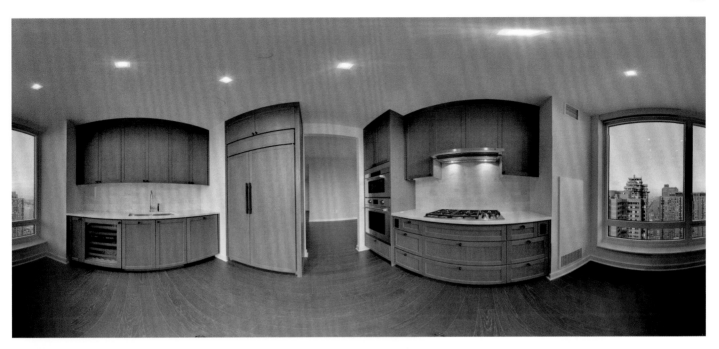

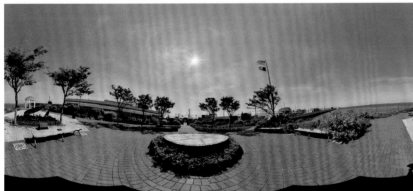

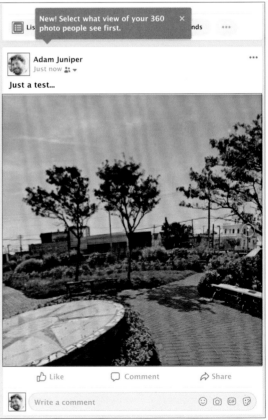

When you compare the two example images at right, you will see nothing shifts behind the reference point (in this case, a light stand). I've got it lined up with the tree in the background so you can see there's no parallax. Once you have achieved this setup, you are ready to shoot.

Make sure you have set the arm perpendicular to the floor. It isn't good enough for just the first shot to be level on the horizon as the camera's built-in indicator may show, since this may change as you rotate. To set the nodal point, place your lens and camera onto the panoramic head and set it to a 60° interval on the base. Make sure the lens is flat at 0° on the horizontal plane, or 90° to the floor.

Situate the tripod around 3m (10 feet) away from a distant and near vertical reference like the light stand and tree in the above images. Rotate to the 30° mark on the panoramic head and then to 60° to see your reference point in the frame from both left and right positions.

Take a shot from each setting and then view your frames, preferably on a computer if possible. You should see no shift between the foreground and background reference points, and the foreground point should not seem like it's moved at all in relation to other elements in its vicinity.

If the background shifts too far inside your reference point, the nodal point is too far forwards – the opposite can be said when the background shifts too far outside of your reference point. Move your camera (see the middle image, opposite page), record the location and try again. Once you find your nodal point, mark the distance on the horizontal slider so you can find it quickly again.

Make sure you have a good shutter release, and turn off any vibration control you may have on your camera, as well as any HDR or noise-processing features. Make sure you have room to take a vertical image by swinging your camera down and face up. If

Above: When you have your nodal point correct, you'll be able to turn your camera and see no relative movement between different parts of the subject – no parallax movement.

Left: The Nodal Ninja is a tripod head that allows you to easily adjust the position of your camera to prevent the parallax inevitably associated with hand-held panoramic shots.

you need more room, then slide your vertical slider up slightly, it's not important to have the parallax bang on with the zenith (straight up) and nadir (straight down) shots. Most mirrorless cameras will fit in nicely, but bigger bodies may not.

If you are shooting indoor 360s, then set the tripod to around 1.5m (5 feet), bring the legs of the tripod inwards so you don't see them and always take a vertical up image. One key item to note here is to always do your panoramas with the character of the room in mind. Unfurnished rooms with featureless white walls can become tough to map when stitching together images in post. One way around this problem is to leave small stickers on the wall near the floor, ceiling or both. These reference points help with stitching and can be removed afterwards in Photoshop.

Outdoors is much the same as indoors, but set the tripod at 1.8m (6 feet) if you can. A height of 1.5m (5 feet) is all right; especially if you are doing both an indoor and outdoor shot as part of the same tour, then you'll want to keep the height the same throughout.

HDR & Histogram
I prefer to shoot for HDR here, but this time in a much narrower way, just three exposures: -3EV, 0EV, +3EV. The histogram should look pretty even, so expose for the darkest area you will be shooting and stick to that exposure throughout the shoot.

Using 360° Software
Choosing 360° software is as much of a minefield as choosing a lens to shoot with, but there are a few stand-out performers out there which take some of the hard work out of stitching.

3DVista is one of my favourites: it comes with a pro package which helps with converting HDR panoramas into stitched, completed spins. As a bonus, there is an automated stitch algorithm that's pretty accurate, but as an override, you can stitch images together manually.

Left, Top & Middle: When mounted correctly, the camera body will be behind the top of the tripod and the nodal point of the lens directly above it. There are two adjustments to make – one near the base of the panoramic head, and one where the camera attaches. Taking the time to get these adjustments just right can save you so much more time later in post-production.

Left: A mirrorless camera should allow enough room to rotate the camera even to a direct upwards view.

Here are two unedited examples of HDR images that have been auto-stitched through software and have almost perfect stitching with no tearing at all. There are a few tricks you can use, including the one I mentioned before about using something like a sticky note to mark a featureless wall for easier stitching. Additionally, ensure all your exposures are identical, which you can check after the software puts them all together to create a sphere.

Once you have managed to stitch your image, it should look something like the images here. Do try and keep your final image to a ratio of 2:1 – 6,000 pixels wide by 3,000 tall or 10000 pixels wide by 5,000 tall, for example – or plenty of programs (including Facebook) will treat it as a flat JPEG rather than a 360°.

Metadata

You might also find yourself with a panorama that, despite all the technical effort, doesn't seem to trigger the 360°-viewing tools when you share it. Once again, make sure that it has that 2:1 ratio (even if you need to disable 'proportional'). You might also need to edi t the metadata (the hidden information in the JPEG file) to tell the viewer to treat it as a 360° image.

You can search online for a tool called the Exifer, an EXIF data editor, and change the camera manufacturer data to say the image is from a 360° camera, like the Ricoh Theta S. Unbelievably, this hack is enough to trick systems like Facebook's image importer into treating the file as a 360° image.

Another option is to source and download a 360° file and replace the existing metadata in your image with its metadata using the Photoshop File Info panel, which has an Import Template option at the bottom.

Below: The small but crucial adjustment in image ratio (from the default into 2:1) between the upper and lower of these shots makes the difference between Facebook's software rejecting it or making it a 360° image.

Opposite: All these shots go into the final 360° stitch. Each of the six bracketed sets gets combined to make one image, and then the resulting six are stitched together.

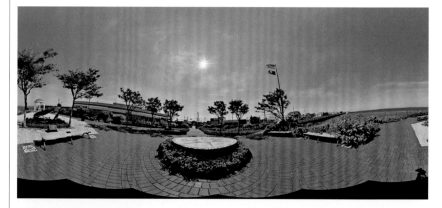

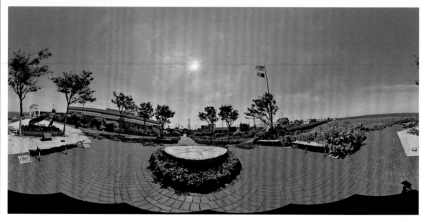

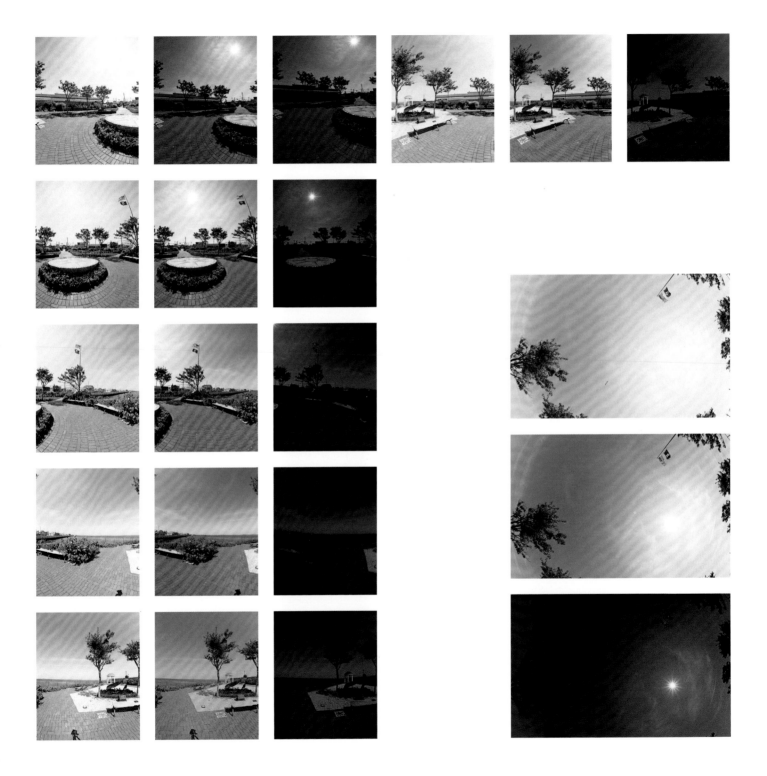

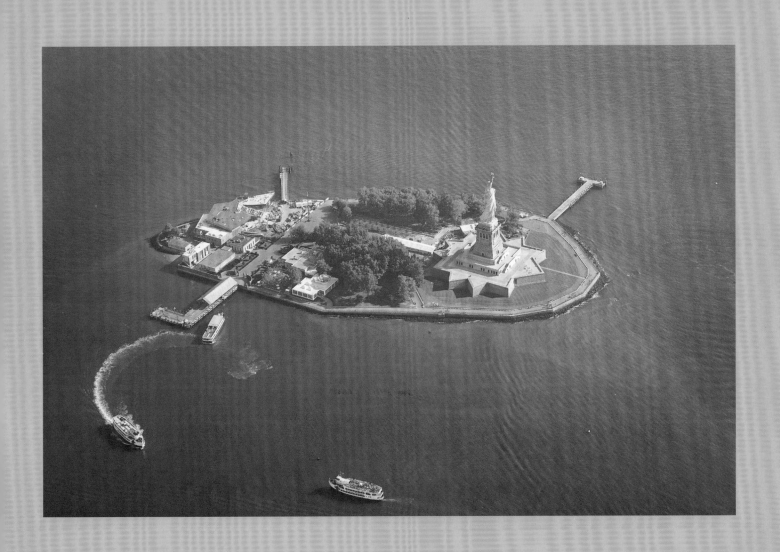

Aerial Photography

You don't need to own your own aircraft. You just need to hire one.

Taking your camera up in a plane or helicopter is one of the most exhilarating things you can do; it's an amazing experience, and everything looks totally different from the sky. It's hard to believe so few photographers do it.

Rushing out and jumping into any airborne mode of transport is a huge risk if you don't know what you are doing or if you have not put any preparation into your first flight. Choosing your method of transport will depend on your needs. In some helicopters you will not be able to switch lenses, especially if you opt for a 'doors off' experiences where all your gear will be locked down. Some planes with a small hole to shoot through are far less strict on what is needed from a security point of view.

My personal preference is a helicopter, especially for shooting cityscapes, but they can be pricey. Some tour operators do offer discounts for regular flyers. If you're unsure what to expect, you can always book a taster flight and take a small camera or phone up with you to practise; this way, perhaps you won't find it so daunting on your second flight. There are other modes of flight to choose from such as microlight, glider and even a tandem hang glider.

The other bit of planning you will need to consider is your location. Get a sense of what you are trying to achieve before you fly, and use Google Earth to see if a location has what you are looking for. Of course there is still an element of risk in regards to weather and how recent that Google Earth image is.

In NYC, Miami, Vegas and other major tourist destinations in the US, there are many 'doors-off' helicopter experiences that can be had for great prices, which help remove the financial barrier for access to helicopters. This is a great way to gain experience (and build your portfolio) before you start chartering your own flights. In small towns, it's worth cracking open the Yellow Pages and reaching out to local flight clubs and schools; they may know a pilot that can take you to your destination for a couple/few hundred dollars in a small craft. Again, plan where you want to go, what you want to see and, if needs be, take a short trip to see what it's all about first before splurging big on a project.

Normally, the warmer the day, the more chance there is that haze will ruin your sight distance. Inner cities suffer from loss of visibility on hot days more than areas in the country. So, plan your day and watch the weather. Most tour-based operators that fly set routes will be somewhat flexible with timings, while a full charter will have much more flexibility.

Kit

Leave your long lenses at home unless your going up in an aeroplane. Wind can really play a big part in keeping your camera stable – or not – so if you're strapped into an open helicopter, your lens will have to fight with downwards draft as well as headwind from the front of the aircraft. Taking a 24mm or 15–30mm lens is best when flying under 600m (2,000 feet). Anything up to 70mm is okay; however, the wider, the better is normally a good rule of thumb here. Be sure to take high-quality, fast glass such as an $f/2.8$ lens. If you are going on a high-altitude flight in a helicopter, an 85mm lens works best.

If you want the option of a longer view, and why not, take two camera bodies, one with a prime lens, and one with a wide zoom. If possible, ask if the operator will allow you to place an action camera somewhere to record your shoot. This is a great way of seeing what you did right and wrong and for getting useful clips for a promo reel. You can even provide commentary while you shoot.

Wear something to cover your eyes like sky diving goggles, or use a strap to keep your glasses on if you wear them. The wind has ripped glasses off my face before, which made for a tricky drive home, so take the precaution if you are flying in a helicopter with the doors off.

Notes

Look out for flight operators in tourist spots to build experience in a price-competitive market.

Monitor the weather before a flight, and try to reschedule your trip if haze is likely.

Shoot with a wide aperture so vibration isn't an issue.

Opposite: There are all sorts of aircraft out there. See what's available in your locale and give it a whirl!

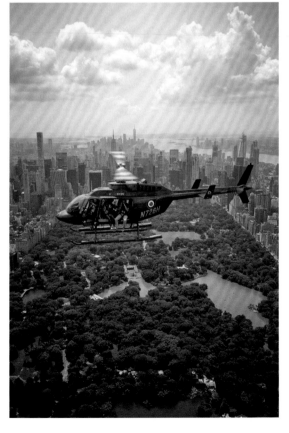

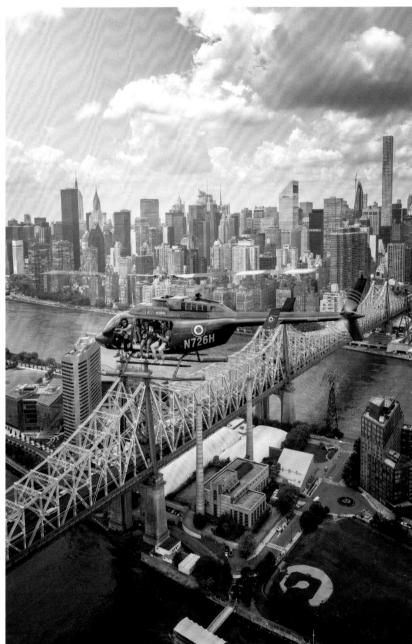

If you are planning to go up into an ultra-light aircraft, take something to protect your legs from the wind; they will get battered around somewhat and new flyers will often instantly regret not having insulated their legs and arms against the wind. It doesn't really matter the time of year it is, it's going to be much cooler than on the ground, so wear some leg coverings such as ski salopettes or quilted dungarees.

Always wear black; everything from your toe to nose should be covered, and wear a balaclava if possible. Your kit bag should also be black; if it has some reflective tabs, then cover them with black duct tape. Since you will be shooting through glass in most planes, reflection will occur at some point, and the only way to reduce it to almost zero is by covering yourself and the seat of the plane in black. An easy way to cover the seats in the back of a Cessna is using a matt black, untapered bed sheet for a twin bed – that is normally big enough to cover up those rear seats.

Make sure the windows are not only completely smudge-free (take some window cleaner of your own and a lint-free cloth just in case), but also single-ply glass. Dual pane or dual-ply windows like the kind you get on commercial jet liners can create so much shadow and reflection that your black coverings will be next to useless as one pane of glass reflects off the other, and bang goes your shoot.

Settings

Your camera's performance will really depend on what you have, but there are a ton of things you can try to give you crisp images. If you are shooting during the mid-morning or afternoon in an urban area, you are competing with the shadows of buildings. So, if you think you may need to recover detail from shadows later on, a neat trick is to enable a small amount of dynamic-range recovery in-camera, or shoot in Raw knowing you can recover two to three stops of shadow.

A great rule of thumb here is the faster the aircraft, the faster the shutter speed you'll need. A great test for this is to take a shot while the helicopter blades are in 'idle'. If the blades are not frozen, take another shot with a faster shutter. Normally 1/500 of a second nails it, but it's a brilliant and easy check to make sure before you get on the aircraft.

Other settings I leave to the camera: I switch to Auto ISO within a 100-to-1,600 range, and I shoot in Raw using AWB so I can change the white balance in post-production if need be. You can save time by pre-programming your camera just before you fly, a practice I highly recommend.

Make sure your Image Stabilization is active both on the lens and sensor if either is applicable. If you have a Pixel-Shift mode, turn that off.

One of the biggest challenges you will have is shooting at night, but check with your pilot. They may have the skills and permissions required to do so, and it is quite rewarding. The lights of city buildings should produce enough light for your camera to pick up, or at least this is certainly the case in large metropolitan cities like New York, Chicago, LA and of course Las Vegas, but be aware of the level of noise you introduce into your image with your ISO setting. Knowing your camera is very important here, and setting the camera to the highest threshold will produce grain, so try and keep that to a minimum, knowing you will have some tidying to do in post-production.

Notes

Wear so much more clothing than you think you should.

If you're going to have to shoot through glass, wear all black.

Faster aircraft will require faster shutter speeds.

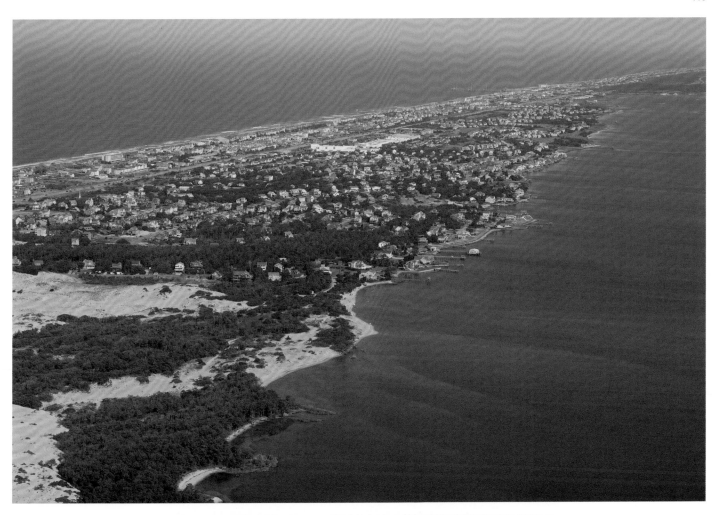

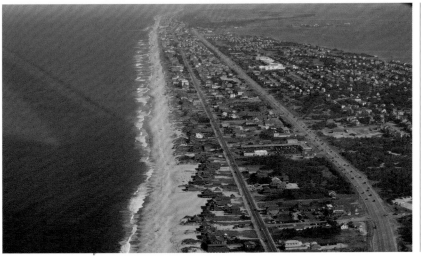

Above: The reflections are completely gone. The above image was shot with as much black inside the aircraft as possible, and by simply being mindful of the light.

Left & Far Left: As you can see here, the inside of the plane is almost completely white which makes for a very challenging shoot. white can cause reflections which you can see in the shot left.

High Altitude

Depending on local rules, you might be able to get a different angle.

Since going higher will bring some fantastic perspectives, it's absolutely worth trying. You'll be well above the 120m (400 feet) restriction on drone flights and therefore able to capture views that have a different look from those which are now abundant. Your images will be less plagued by converging verticals, and will have a more satellite-like quality.

At higher altitudes, atmosphere plays a much bigger part in your image-making ability. Those summer days will bring plenty of haze and possibly even small, low-level clouds, so pick days forecast to be cooler and cloudless. As you can see in the views of Columbus Circle in New York City taken at the end of August with an 85mm lens from 2,000m (6,500 feet), there were some challenges with cloud cover and haze. However, you can still make images with clouds and haze look beautiful, and you can frame your shots nicely as well.

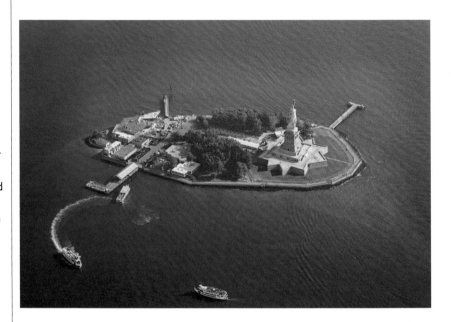

Above: Captured at around 400m (1,300 feet), the level of haze is low enough that it can be reasonably effectively eliminated in software.

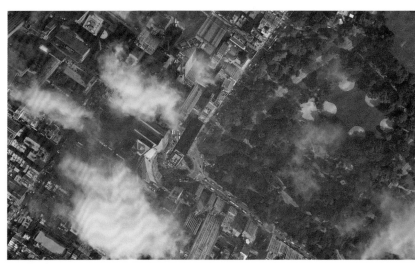

Above & Left: Columbus Circle in the corner of Central Park, New York, seen from 2,000m (6,500 feet) with an 85mm prime lens.

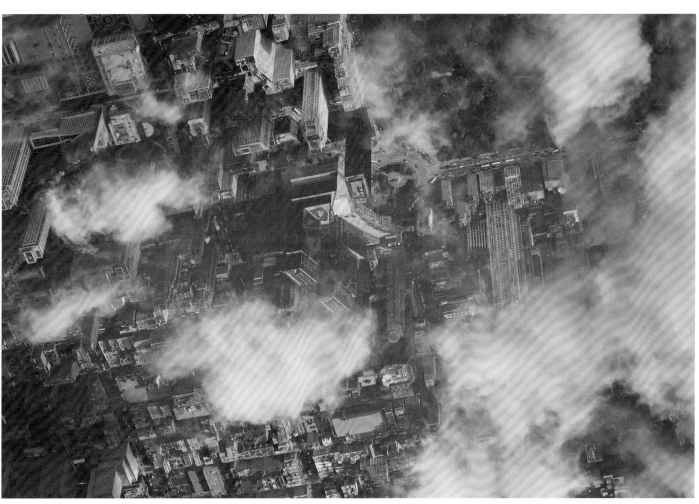

Best Cameras for Aerial Photography

Shooting from a 'doors-off' helicopter over NYC is one of the most thrilling and rewarding experiences I've ever had, not only in flying but in photography as well. So here is a quick rundown of some of the cameras that I have found to really shine while working with FlyNYON, who run doors-off helicopter tours in NY and Las Vegas.

Canon EOS-1D X Mark II

The Canon EOS-1D X is an amazing camera for aerial shooting. It gives you the flexibility of having a single platform that shoots amazing stills as well as 4K video at 60 frames per second. Having these two capabilities in one body allows you to change modes with the flip of a switch, so you don't end up missing a shot.

Panasonic Lumix GH5

If you want smooth cinematic video, the GH5 is the camera you want to use. The Micro Four Thirds sensor with in-camera stabilization delivers epic cinematic 4K footage. This platform is also incredible for shooting silky smooth slow-motion shots as it has the capability to shoot 1080p video at 240 frames per second.

Sony a7R III

Looking for incredible detail in your shots? The Sony a7R III with 42.4 megapixels will deliver shots with an enormous amount of detail. You will not have to worry about image quality degrading if you need to crop in on an image during the editing process to get the perfect frame. This body will also be perfect for photographers looking to blow their images up to a large size.

Canon EOS 5D Mark IV

An all-round great body for shooting aerials is the 5D Mark IV. From its resolution to its colour science, it's the perfect camera to take up with you in any scenario. FlyNYON content team's favourite combination is the 5D with the Canon 16–35mm

What kind of gear should you take into someone else's aircraft?

f/2.8 lens, which gives you the capability to get those wide, epic shots.

iPhone Camera

The one piece of gear the FlyNYON content team and 99 percent of their customers take up every time is a smartphone. The iPhone has an incredibly versatile camera that exposes images correctly for you, has great 4K video at 60 frames per second and has a good Slow-Motion mode. Burst mode on an iPhone guarantees a good shot when passing by iconic landmarks.

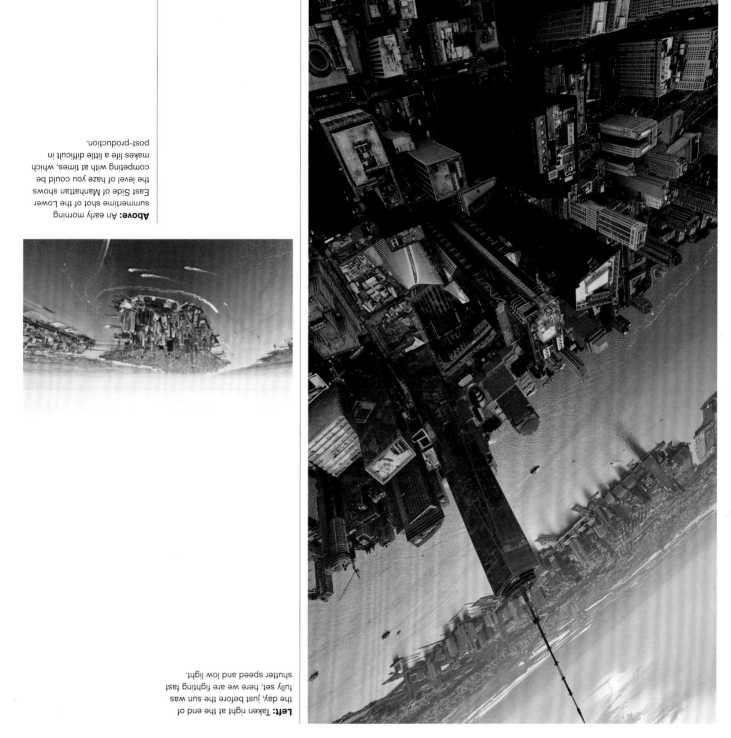

Left: Taken right at the end of the day, just before the sun was fully set, here we are fighting fast shutter speed and low light.

Above: An early morning summertime shot of the Lower East Side of Manhattan shows the level of haze you could be competing with at times, which makes life a little difficult in post-production.

Drone Photography

Flying a drone allows you to capture much cheaper aerial shots, but don't forget the paperwork.

Drones are the best accessory you can have in your kit bag, and – at least in pro-photography terms – they need not be horrifically expensive. The Parrot Anafi or DJI Mavic 2 drones, among others, offer 4K video recording and can take still photos which can match a DSLR's resolution.

Images from most consumer and prosumer level drones, and even some professional ones, are captured by cameras that are built into the aircraft. Professional-standard drones are actually surprisingly easy to control once you've understood the basics. Built-in altitude, movement and position sensors and a processor mean that, unlike the fiddly toy drones kids get at the holidays, a camera drone will simply hover exactly where it is left when the pilot lets go of the control sticks. Modern drones, by the way, can hover for around 20–30 minutes (the pro-level ones somewhat less, since they weigh more).

On top of that, automated take-off and landing modes, usually actuated with the touch of one button, collision sensors and software that monitors the on-board battery situation (and, if needed, brings the aircraft back) mean that you can concentrate on what the camera is seeing.

You might think that four or more fast-moving propellers above a camera would cause problematic vibrations, but manufacturers mitigate this not only with dampening materials but with motorized gimbals. All of this provides stabilization similar to that built into some camera bodies and lenses. You'll generally be shooting in good light (indeed, night flying is normally banned), which means you won't really have a problem with blur. The other vital purpose of the gimbal is in combating the wind. Because of the way multicopters are designed, they need to lean into the wind to stay in the same place, so a powered gimbal can automatically counter this effect and keep a level horizon. Horizons are an issue with plenty of aircraft, so it is important to familiarize yourself with the calibration procedures – the older the drone, the more onerous they will be. Some drones need to be reset by running a calibration through the menu, and then must be tweaked in flight using the controller. More recent models are better able to maintain their calibration.

One aspect of the optics that some photographers tend to find a little surprising is the rarity of interchangeable lenses, and indeed even zoom is unusual. The engineering required to balance gimbal motors and the weight in general means that you're going to need to invest several thousand even for a Micro Four Thirds system, and those drones, like the DJI Inspire series, are not easily portable. Fixed, reasonably wide optics (28mm EFL for the DJI Mavic 2 Pro, for example) are the most common.

Just as with a regular camera lens, if you do have a zoom drone, you'll find a greater risk of vibration at the longer end of the zoom. This can be mitigated with a bigger, more stable aircraft – or simply by flying in better conditions – but this is part of the reason that zoom hasn't been offered on many aircraft until recently; it was simply asking too much of the gimbal.

Below: Two generations of the fold-out DJI Mavic drone; the one on the right has a zoom lens.

Notes

Be aware that the smaller image sensors found in drone cameras do have their limits.

Position the drone to frame a shot how you want it, as this is a much more economical option than purchasing a drone with a zoom lens.

Above: A drone allows you to put a property in perspective in a way no other approach can. Here, the 50m (164-foot) altitude shows the Manhattan skyline in the background.

Left: A wide view over a working dock splits the frame perfectly between sea and sky, with the eye always drawn to the action and colour in the middle

Unless your plan is to make drone photography your main income, you should find that a foldable craft is still the ideal extra in your travelling pack, not much bigger than a regular lens and just as portable. Smaller drones also use smaller, more portable accessories, the principle one being batteries.

Something that almost every drone pilot will find they need at some point is neutral density (ND) filters, which can be found from camera suppliers for all major drone models. You'll often be shooting well-lit environments and may find you'd like a little control over the light. You can also find polarizers. You'll need to get specific ND filters for your drone camera. Filters for the DJI Mavic 2 Pro and the DJI Mavic 2 Zoom, despite identical airframes, are different, as the camera units are different.

The main obstacles to drone operation are legal, and, irritatingly, these regulations vary as you travel. There are common themes. For example, just about anywhere you go, you'll find a maximum flight altitude of around 120m (400 feet) which you mustn't exceed, as this is reserved for other aircraft. Another widespread regulation is an outright ban of flying over residential areas, crowds or near certain building premises, especially airports. You're also required to register all drones over a certain weight, and that weight limit only really excludes tiny toys. A DJI Mavic needs registering in the US, for example.

In the UK, you also need a qualification overseen by the Civil Aviation Authority if you're planning on doing any commercial work. ('Commercial' is interpreted strictly – even a monetized YouTube channel counts.) The qualification is available from numerous test centres.

In virtually every country, you'll need public liability insurance to cover against the very unlikely, but pretty dramatic, potential consequences of a problem. You'll also need landowners' permission. You'd be surprised how often you will find this withheld by well-meaning, safety obsessed local councils or other regulatory bodies, or at least charged for by more mercenary ones. All of this requires research. In addition to that are the usual rules about building design copyrights, should they be relevant.

Dual Operator

If you decide you'd like to capture more ambitious drone photographs, then you can switch from working on your own to working with a second operator, a separate pilot. This involves both individuals using a remote and controlling some aspect of the drone's operation. Multiple configurations are possible, but the most common is where one person flies the drone and the other operates the camera. This arrangement is, in practice, of little extra value for stills, but it does make a lot of sense for tracking moving objects in video.

If you prefer to work alone or this feels like overkill, don't fret – even that tracking task can be handled by software on more compact drones. The software is capable of rotating the craft as needed in a way that is effectively the same as the two-pilot operation on a rather smaller budget.

Notes

ND filters for drones are model-specific.

Know the rules in your area. Check either the FAA.org site (USA) or droneaware.org in the UK.

Dual Operator mode makes more sense for video.

Left: Captured with a Parrot Anafi, this shot shows a good deal of detail, but it does test the dynamic range of the sensor. It would have been better with an ND filter, which are available for drones.

Above: Captured with a DJI Phantom 4 Pro, a drone with a 2.5-cm (1-in) image sensor, using the built-in HDR function. As you can see, the detail in the sea and the tonal range suggests no need for a 'real' HDR camera.

Drone Panoramics

Modern drones automate the process of capturing panoramas without the need for tripods.

Drones and panoramas go together hand-in-hand, not least since all modern drones are able to take the hard work out of the process entirely. Most will allow you to select a 'panorama' option and will then capture the image for you.

Some, but not all, will also capture 360° images, which can be viewed in the Facebook feed or with 360° viewers. At the time of writing, one model, the DJI Mavic 2 Zoom, will also zoom in on a shot you compose at 24mm EFL and shoot-and-stitch from as many frames as possible for a higher resolution. The only real downside with this (and indeed all panoramas from multiple frames) is that things can and will move between frames, so think about the best way to capture your view, and perhaps get a second shot for safety.

Notes

Check your drone's menus for the panorama options.

If shooting 360° images, be mindful of how the sun will affect exposure.

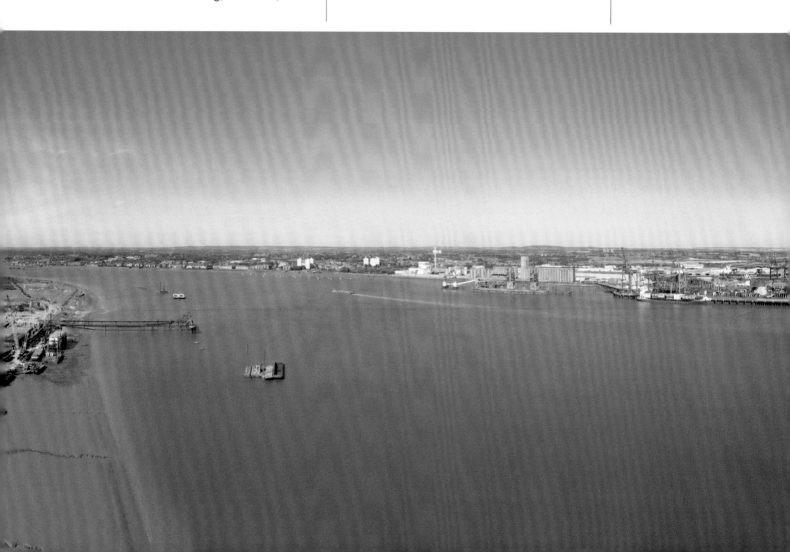

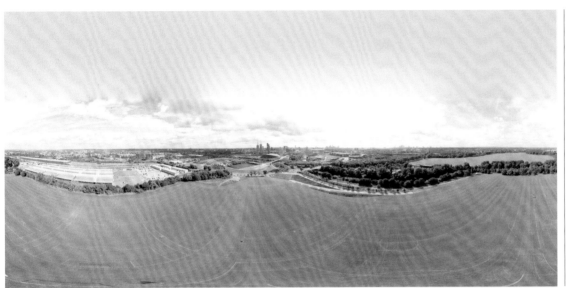

Below: This is a 180° panorama shot using a DJI Mavic 2 Pro, which, as you can see, makes a successful job of compensating for the light. These stitched images are available to download from the device as JPEGs almost immediately after they've been captured.

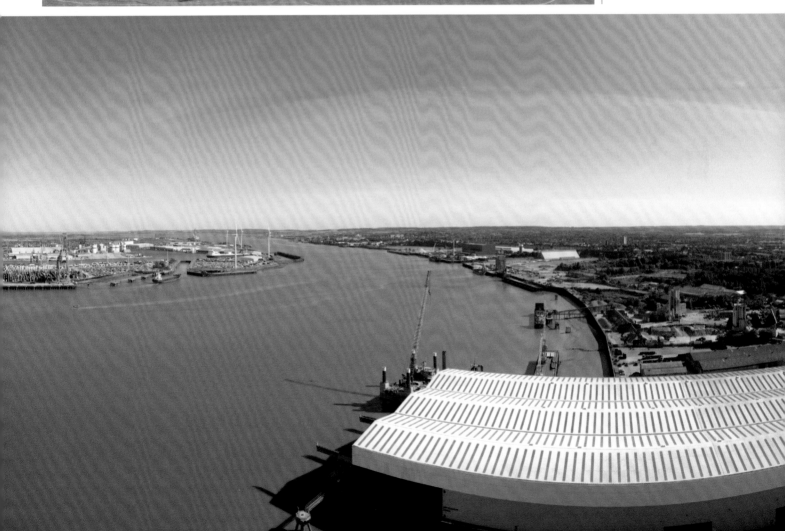

Drone Video

Don't forget that still photography is only part of what your drone can do!

Low-altitude aerial imagery is stunning, but it's really only a secondary function of drones from the perspective of the drone community. Video cameras were fitted to early drones – GoPros usually – then low-resolution video cameras for piloting purposes. Only with more recent systems with higher-quality digital cameras and digital feeds to the pilot's monitor (their phone), have good-quality stills become part of the manufacturers' thinking.

Since photography is the key focus of this book, we won't dwell on video in too much detail, but even photographers should experiment with 4k moving imagery caught from the air, if for no other reason than a single still from the video is an 8-megapixel image, and you're often likely to be in a position where a still from a video will suffice, plus you'll be less likely to miss the shot you want. Some drones, like the Parrot Anafi, perform adequate HDR processing on the video, so you may even find no additional work is needed. The three shots to master are:

God View
Looking straight down on your subject is dramatic even as a still, and you can introduce an unusual rotation in your composition to add to that. Take it a step up, to moving video, and you can see the perspective of every building, person or tree that you fly over, even if you just move the drone forward slowly at the same altitude.

Strafe/Dolly
Moving the camera along a dolly track is a great way to gently reveal the perspective of a scene (and one much loved by filmmakers). Even a fairly boring-looking level landscape starts to liven up as foreground objects move more quickly across the frame than ones behind them, creating a sense of reality which still photography can only really hint at using a shallow depth of field. This video 'trick', on the other hand, allows the viewer to choose what to look at, as all will be in focus.

Orbit
Even easier thanks to software assistance which can track a moving subject, orbiting even a relatively boring subject like the tower illustrated opposite can lift it out of the background. If possible, use a longer focal length or, failing that, back off and crop from 4K to 1080p in post-production.

Notes

Even if you only shoot video for the purpose of extracting stills, you might still find you have a showreel.

Some drones can take these types of shot for you, but it's better to practise them yourself.

Left & Below: God view: looking straight down on a subject from a moving drone.

Far Left, All: Tracking along an imaginary dolly in the sky can create a great parallax effect.

Left, All: Orbiting an object makes it stand out in a way it doesn't appear to when still. Keep it in the same position in the frame.

Going Underwater

A different world, but one you can get your camera to with the right gear.

I get asked quite a bit about how photographers can improve their photography underwater. The first thing I will always say in reply is, how good are your diving skills? Many basic PADI divers struggle to keep their dive time up to get to a level where they can concentrate solely on photography, and this can damage the environment as well if they can't maintain a steady buoyancy. So, bear in mind, these tips are for those who can dive consistently without compromising their safety. Also, I'll assume you have taken the PADI Underwater Photographer course. If you haven't, then take it; it's great!

Make sure you plan each dive very carefully as you could waste valuable air when faffing around underwater without a plan for you and your dive buddy. If you want to take the planning element out of the equation, then join up with the many tours available.

Selecting a Camera

Knowing your camera inside out is imperative to underwater photography. And choose carefully from the range of underwater housings available for your camera. It's not all about the camera itself, make sure you're comfortable with the housing you use, as this will make or break your shooting experience. The way you attach accessories, the way the casing shuts and the level of maintenance required are all to be considered. Almost as important are your hands, as your dexterity will be tested to the max. Test the housing with gloves of all types to make sure you can reach the buttons, engage with them and feel them without looking.

It would almost make sense to look for a housing and then ask which camera brands it can hold – the choice is that important. As for the camera itself, get the largest format you can; full frame over APS-C makes a lot more sense in a world with less light, since you want to let the maximum possible amount of light in.

If you can find a housing that allows it, using the rear screen can have some huge advantages in underwater photography. This is something the mirrorless cameras and some compact cameras excel at. DSLR cameras have a live-view mode but sometimes this doesn't contain all the rear-screen information a mirrorless does.

Selecting a Lens

Selecting a lens will depend on what kind of shoot you are planning, but 24–70mm is a pretty popular choice for a range of purposes. Keep in mind, however, most zoom lenses have a relatively long minimum focusing distance, so for photographing things like marine wildlife close-ups, select a macro lens. For wider shots (on a full-frame camera), use a prime around the 16mm mark, especially for larger marine wildlife. If you have an APS-C camera, then a 10mm, or even a fisheye, would be a good choice for some brilliant creative options.

Notes

Make sure you take the PADI Underwater Photographer course.

You can take dive tours to build your confidence and stock portfolio while leaving the planning to someone else.

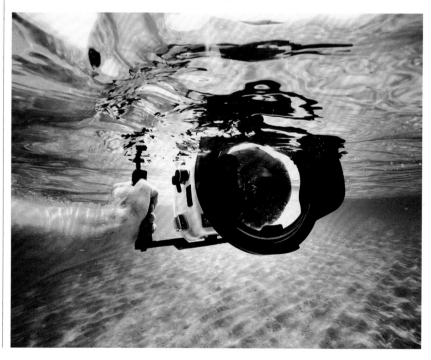

Above Left: Serious diving is a specialist area, with specialist gear and specialist training. You should definitely give it a try before you even think of taking a camera, in case it turns out you don't enjoy it!

Left & Opposite: Underwater camera housings can be somewhat restrictive if you're used to constantly accessing your camera's settings.

Above: There is a magical atmosphere underwater, which you can capture in your shots.

Composition

Remember, just because you're underwater doesn't mean you have a new set of rules for composition. Keep your Rule of Thirds guidelines on, as they will give you a reminder when a shot still needs some work.

Try to include something in the background, such as a fellow diver holding a torch, to create an element of depth or the expansive nature of the ocean. Pretty much all the best underwater photography images I have seen combine the two elements really well.

Bokeh, or background defocus, isn't always your friend underwater (the tonal effect of the water itself will go some way to providing an alternative way of perceiving depth). Try and keep that f-stop dial above f/5.6 to show what's around your subject.

Fish, Flora and Fauna

Getting close to your subject is key to capturing great shots of fish, flora and fauna, because the light underwater is reduced in terms of colour, contrast and sharpness as the water acts like a giant filter between your camera sensor and your subject. You will see plenty of colour from as far away as 60cm (2 feet), but at 50cm (1.6 feet), you should be more than close enough to get all the detail required to make a great image. Try and take the image at the subject's eye level, as just like your portraits, that's much more flattering.

Before you go in and get all trigger happy, there are a few things to be aware of: your interaction with subjects matters, not only to marine life but also to yourself. Spooking marine life can interfere with your dive party and create murky conditions very quickly.

Always approach wildlife with caution and think about how you can get the shot and remove yourself from their territory as quietly and quickly as possible. Slow your breathing for the last inch or so, as marine critters are more scared of the bubbles from the regulator than they are of you.

Natural Ambient Light Underwater

Shallow water is the place to shoot if you're not using flash, as the light from the surface is nice and close. The sun on a bright day can provide light in depths of around 10m (33 feet). Also, some shallow areas can be accessed by snorkelling or free-diving.

Shooting without flash means you always have to have the sun or your light source behind you. It's tricky, but you don't ever want to get in between that and your subject. Creating a shadow can have an impact on your ability to capture colour. As soon as you're under the surface, even on a bright day, you may need to ramp up your ISO to around 1,000 to get a fast enough shutter speed for crisp, blur-free images. Remember that the camera is moving as well as the subject.

Below & Opposite, Top: The underwater world is a whole new territory to explore.

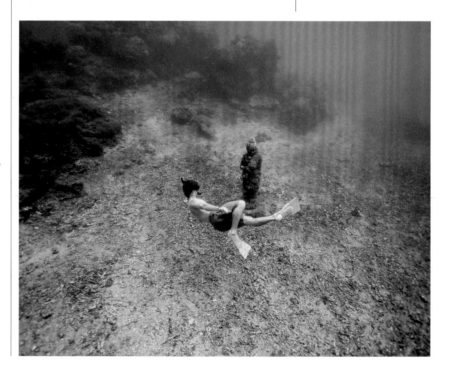

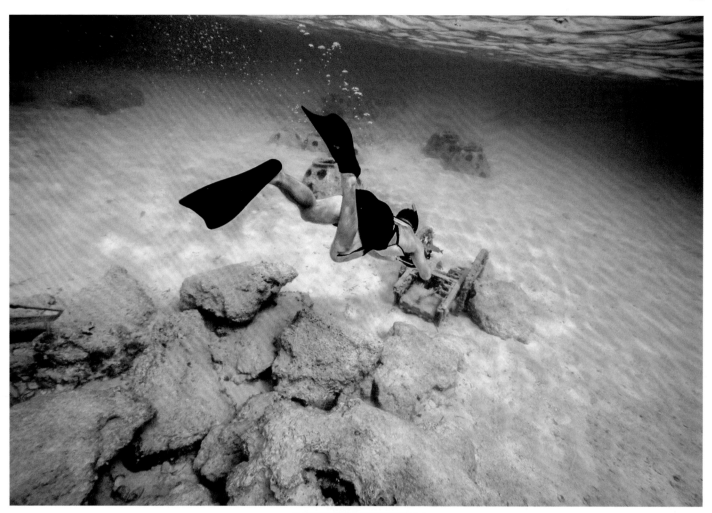

Left: Look for still-life opportunities where you can and make the most of the beautiful natural light underwater.

Underwater Flash

Illuminating the sea.

Creating artificial light underwater can present a whole host of problems, mostly because many underwater photographers use the on-camera flash. Not only is this quite harsh on the eye and the resulting image, it can also overpower the colour range, meaning only a small section of your image will be colourful. This is especially true if you're using a wide lens.

Nonetheless, adding flash is important, especially as it can help offset the changes in colour caused by the water. Warm saltwater acts like a giant blue filter, and as the water gets colder, the more it tends toward green. Flash light is usually the same as daylight, so – at short range – it'll cut right through that, freezing your subject and illuminating them as they are.

Adding two off-camera flash heads that sit to either side of the camera, one slightly higher and one slightly lower, will create a lovely wall of light that will carry for about 0.9–1.5m (3–5 feet). There are many guides out there that will contest flash should be used this way and that way, however I have found this 'wall of light' method works best for me.

Diffusing the light is imperative to your success as well; making a wide spread of light is one thing, but using the housing diffuser will also create a softer feel to your composition. One hack that I use for underwater flash is applying clear sticky tape to my flash head, which is normally enough to diffuse the light without blocking a whole stop of light from entering the frame.

Also, with flash, you are limited by the sync speed of the camera, typically this is anywhere between 1/200 and 1/250 of a second. It should be enough to freeze any subject, and if you wanted to keep the flash in TTL mode (nothing wrong with that), then do so.

Set the flash to underexpose by a third of a stop so you will never overpower the scene, and if it's a tad dark, you can always recover detail in post-production. That said, TTL does have a habit of underexposing underwater. The alternative is to use manual flash and set it to half power, depending on your unit. You'll have

to experiment with your specific equipment, but with the most powerful heads, I do set them to half power and then adjust my camera settings or close up the aperture as needed. That way, I just have one dial to worry about and not two.

Colours will be more sensitive to shutter speed changes than aperture, especially the colour of the ambient water around you. Slower shutter speeds make the scene more blue; faster, more green.

Backscatter

An issue you'll encounter with flash, even in apparently clear water, is the number of small particles floating in the water that your flash will illuminate. This is where an external light, held away from the camera and pointed towards your subject, can work wonders, since not only can you model the shape of the subject (as you would when lighting in the studio) but the particles reflect in other directions.

Notes

Waterproof flash housings are available from major photography suppliers.

Flash combats the tonal shift of the sea as you get deeper.

Backscatter (illuminated and reflecting particles) can be minimized by lighting your subject at an angle.

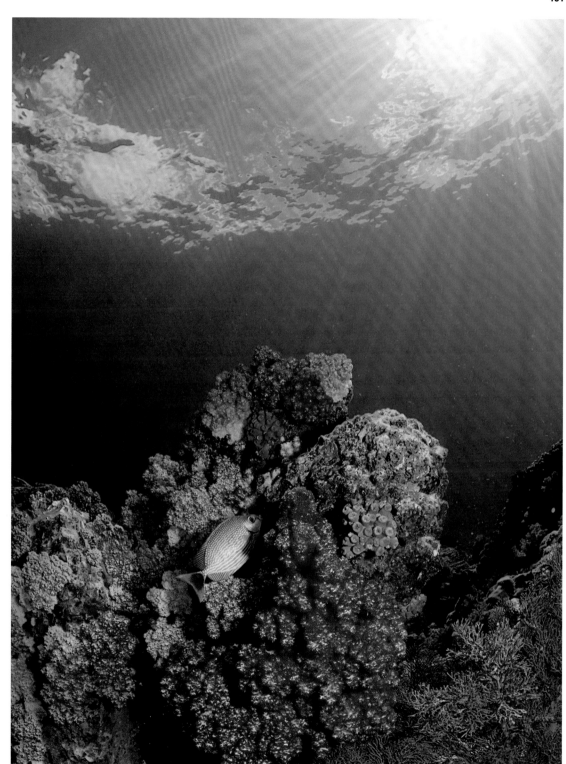

Right: The effect of a flash, held slightly to the right, is to bring out the colour in the coral. Even this close to the surface, with the sun shining through, its very apparent how much more colour there is in the flash-lit parts of the image.

Opposite: Jellyfish, close to the camera, deep enough that only the flash is providing light.

In & Out

Half in the water, half out.

This is something you can do with your underwater gear or, failing that, a jar and a smartphone, and it's well worth getting a few of these types of shot as they can be even more eye-catching than full underwater images.

Staying near the surface is a good thing anyway. The light immediately below the surface of the water is the most 'natural' to the viewer's eyes. The deeper you go, the bluer everything gets because the sea acts as a filter, limiting the red and green lightwaves first. Artistically capturing an image that shows us both sides of the surface is a little like breaking the 'fourth wall'. It's jarring, and it grabs attention when used to good effect.

Fish Tank

For surface-level shots, there is no need for a fancy and potentially expensive underwater housing. All you need is a small fish tank which you or an assistant can keep from sinking, ideally resting it on something in the shallows. Don't fill it with water. A cubic shape with flat (clean) glass is better than a traditional fishbowl, unless you're looking for some optical weirdness.

Keep an eye on the glass. You'll need to maintain a clean surface. Regularly remove the glass and thoroughly clean it to avoid salt residue drying on it. You'll likely find you get the best shots as you first submerge the camera in the tank. Before you do, set the focus manually on your surface subject (don't use too wide an aperture – you'll need enough depth of field to allow for a little drift). Then select Continuous drive mode so you can move the camera around in the tank, capturing a series of frames as you go. Pull the whole thing out and review the results. Clean the glass of the tank and go again if you don't get anything you like.

Jar

Modern smartphones are either waterproof or splash-proof up to a certain depth (though you should be absolutely sure that yours fits this criteria before you try this). If yours is, you can submerge it in a jar to get a similar shot. There are also waterproof cases designed for beach use – dry bags – which are far from optically ideal but do at least allow you to experiment around the surface of the water.

Notes

This technique is a great way to get a new perspective on popular beach locations.

Use a square-sided fish tank if you don't have a housing for your camera.

Strength in the sides of the tank is important as water exerts a lot of pressure, especially with a big tank.

Use Continuous shutter as you submerge

Above Left: Flamingo toys are the unicorns of the sea! Leaning the camera back in the shot gives it a certain majesty it didn't have in the beach hut shop.

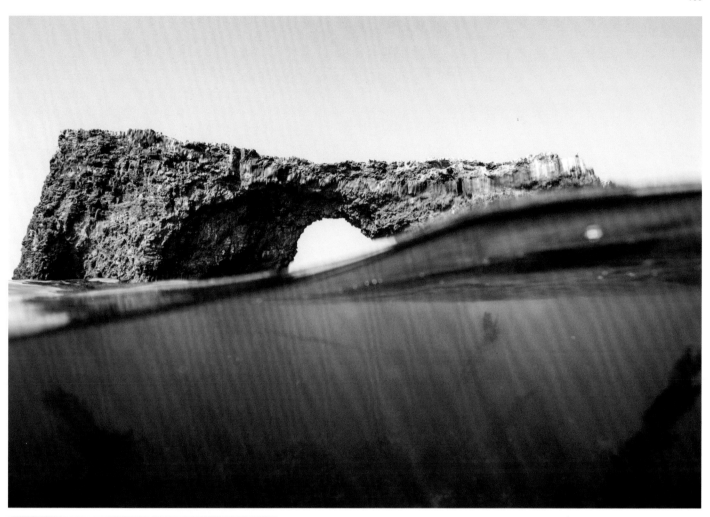

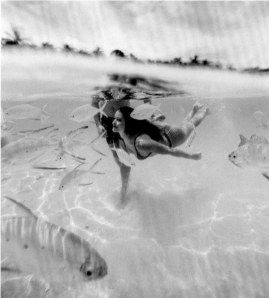

Above: An arch in the sea is a spectacular subject, but one which will have already attracted a lot of conventional shots. This technique offers us a fresh take.

Left: A classic example of this type of image, which has been used by those looking to promote the Maldives as a tourist resort.

Upside Down &
In the Drink

Use the reflective properties of the water's surface and the oldest trick in the book.

You might call it the oldest trick in the book, and in a way it is, but age or not, it's only a useful trick if you remember to use it. It's also slightly trickier to pull off than it might look.

When you're shooting underwater, the bottom of the surface is partially reflective, and it's possible to get an interesting shot if you can get the surface still enough to use as a mirror. This is impossible in rough seas, but near the shore on a very calm day, or in a controlled environment like a pool, you might be able to pull it off.

The fun is to be had when your subject breaks the surface, because viewers then need to take a harder look to see what's going on. You can make that moment take even longer by turning the image upside down (flip or rotate) in Photoshop or another image editor.

Whichever way up you present the image, the effect works best when your subject is strongly lit, either from a very sunny surface or from inside the water. You need to be far enough from your subject that there is room for the reflection in your composition, making the angle of incidence less than 42°. This is the point of total internal reflection, and occurs because light at a slight angle takes a slight turn (refracting) as it hits the surface of the water, and after a certain angle, some reflecting in, and some refracts out of the water. Narrow the angle enough, and none is refracted out; this is called the angle of total reflection.

You might need to find ways to control your breathing to avoid playing a part in disturbing the water's surface yourself, depending on how calm you want it. As you can see from the examples, some rippling can have artistic merit.

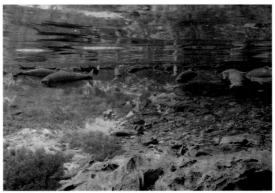

Notes

Use distance to get a narrow angle of incidence.

Do all you can to avoid disturbing the surface.

Left, Top: Right way up, the fish reflected in the surface make this shot a little more interesting than if they weren't there.

Left, Bottom: This image uses the same phenomenon for a different effect; to show off the dress but not make it about the model's face. She is captured underwater and right side up, providing the photographer the opportunity to let the fabric flow.

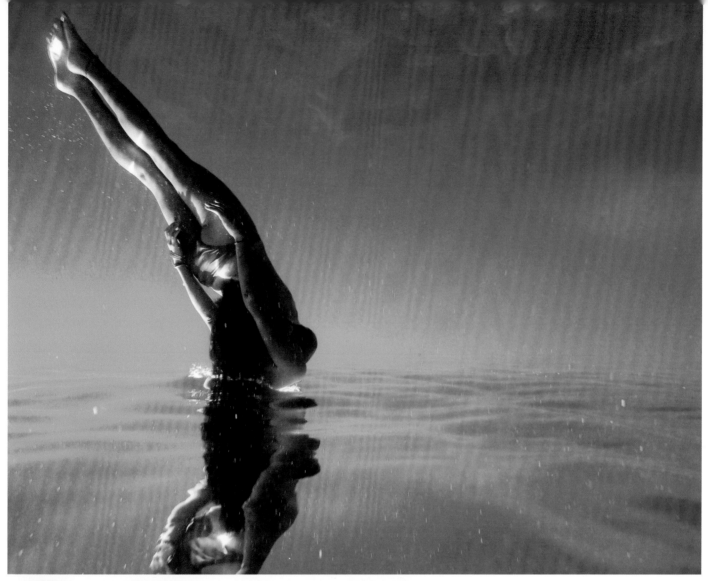

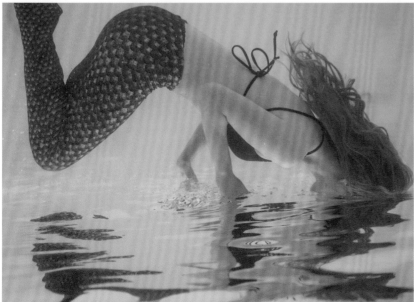

Above: An underwater shot in calm water flipped upside down in Photoshop. To achieve such a still surface, the model needed to swim underwater a little distance before turning up.

Left: Another underwater shot in less calm water flipped upside down in Photoshop. Clearly there is water, but it takes a moment to realize that the model is already in it.

**Lifestyle &
Concept**

Food Photography

If you've not experimented with this market before, now is very much the time.

Turnover in the restaurant trade is high, and successful restaurants keep their menus up to date. Delivery apps mean good images are more important to restaurants than ever, so however you look at it, this is a market well worth exploring.

For these tips, I will ignore plating skills and concentrate on the technique of creating great images. Just a side note on food, don't let it sit around too long, as it can change very subtly over the course of a few hours, so keep an eye on that, and keep all your images consistent if creating multiple scenes.

For the actual photography, it's 100 percent worth grabbing some reflectors, diffusers and black cards. These items will make it so much easier to control your ambient light. (This is a genre of photography that works best with ambient light.) If you don't have access to ambient light, then that's okay, we can use the diffuser.

Camera Angles
The easy part about food photography is choosing a camera angle to use. There are a few options, but the most popular is the straight-down and the low-angle-side-on. Your camera angle choice really depends on the food you want to shoot. My general rule of thumb is: the more complex the dish texture, the more likely I'll shoot top-down. For simple food, I will shoot side-on at a low angle. The other factor here is any branding you might need to include, or if a particular style is required. If your goal is to create a sense of location, then side-on is better, as you can tell a story with the background.

Creating a Scene
When shooting side-on, you have a wide range of choices: you can blow out the background with light, keep it dark with a more spotted light hitting your subject or even include people in the background with a heavy amount of bokeh by keeping your aperture wide.

Including props that add a sense of context to the dish works really well when shooting top-down – you can make this kind of shot quite conceptual. For side-on images, which are often less conceptual and more 'realistic', including some relevant accoutrements in the background is a good way of adding interest. If you were shooting a hamburger in a diner, for example, you could include brightly coloured ketchup and mustard bottles. Be careful, however, not to add props or anything that will distract from or upstage the food.

If your food is full of colour, think about selecting a plain plate or dish. This way you can really make the food pop.

Diffusing Light
Using a high-quality diffuser is the key to creating fantastic food images, as you want neither hard light nor heavy shadows. Always have a white bounce card at hand as well to fill in the shadow if need be; alternatively, if you want to encourage some well-placed shadows, the black card will work really well.

Top-down shots will need some attention to make sure the shadows are not too deep, especially on food that has high peaks. Placing the food at about 55° to your light source will be enough in most cases.

Side-on shots will almost always need some light to fill shadows on the far side of the subject. Again, this will depend on how high you place your light source, but if you're using ambient natural daylight, then a white or silver card is all you need.

Some flash units can be hidden behind a matt white translucent shower curtain, which can give brilliant, soft light. Just make sure that the colour of the light coming out of the curtain matches your ambient light. Or, you can use filters to balance the location's light with artificial light from your flash. Use a colour meter if you are unsure of the temperature of the local light. For the reasons already mentioned, I always try to use ambient light from a window, combined with bouncing that light as much as I can.

Notes

Light at an angle of about 45° and a diffuser are the key lighting elements to start with.

Don't skimp on the set dressing.

Time is a factor; discuss with the chef how long the food will stay looking fresh. With egg yolks you have only seconds, while a cookie will last longer.

This Page: The top-down perspective is a classic, as is a low, side-on shot. In each case, though, the environment is carefully controlled and complementary colours chosen.

Whether it is a complex dish cooked by an experienced chef, or the most ordinary of raw ingredients, your role as a photographer is to understand who will be buying the food and what they're hoping to get from it. The client should have some clear direction here, but if they're wavering, you might need to show them the way.

Context is everything. It should go without saying that the actual food itself will be a key part of the image, and that you will shoot it to the best of your ability, but the real success will come from dressing the scene not only to look good but to complement the client's goals. In short, heath food shouldn't be seen on a table that belongs in a greasy diner, and a burger might seem a little uncomfortable next to a field of carrots.

Props, including the table surface and plate, are the real key to getting across the lifestyle you're linking with the food you're photographing. When it comes to setting the scene, are you looking for rustic, classy dining or something else? If you're shooting for a restaurant, chances are they'll have a 'look', so this work is done for you, but it doesn't hurt to have some of your own props to hand.

Ambient light, or window light, has become very popular among food photographers because the soft shadows it provides feel natural, which subtly messages the consumer about the quality of the ingredients. This can of course be achieved with a large softbox, but the goal should be the same.

Your choice of either shooting time, white-balance adjustment or light gel (depending on your preference) makes a difference. The light in the morning is slightly bluer than at midday, and the light in the evening tends – as we photographers know – towards golden before becoming dark.

If you're using natural light (or simulating it) the light should be appropriate for the time of day the food being photographed would normally be eaten. Shoot breakfast foods in morning light, lunch foods in afternoon light, etc. For evening meals, all bets are off,

of course, and you'll have to make your own decisions (or be guided by the tone of the client's establishment, if there is one). Perhaps an early evening shoot, while there's still some daylight, would be appropriate; or maybe you'll have to use entirely artificial light.

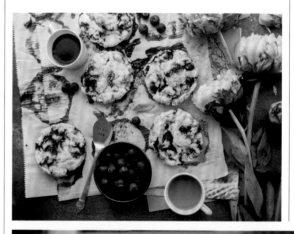

Notes

Don't send mixed signals. Be sure to have fresh/ripe ingredients!

Shoot foods with lighting appropriate to the time of day that they are eaten, whether using natural or artificial light.

Left: A home-baking process is suggested by a degree of artful messiness, the 'lifestyle' defined even further by the carefully chosen flowers and accessories.

Above: The meal is a healthy breakfast. If you're selling the yoghurt which lies beneath the fruit, you have a challenge: we all know what yoghurt looks like. So, the solution is not only to add the fruit, but to add elements to the framing that remind you of a fresh new day, including the ambient, soft light with a hint of blue.

Opposite, Bottom: Don't forget that the lifestyle might also include the venue. Here, a hipster street stall is the scene. The ambient light is actually emphasized only by the table lamp seen in shot.

Right: Here, the food is about having fun, so the presentation is designed to hint at somewhere bar-like. The bottle caps (from interesting brands) and vintage drinking glass help with this, but the real winner is the multiple forks; we know this is a sharing platter for people with friends.

Fine-Art Still Life

Change a scene completely with careful (or liberal) use of paint.

This is a technique which won't so much stretch your photographic skills as it will your abilities with a paintbrush. If your goal is to capture a certain aspect of an object and make it stand out, whether for an unusual book cover, an attention-grabbing thumbnail to be used as click-bait, for stock, or some other purpose, it can be tempting to add a great deal of colour and detail. The alternative is simply to paint out everything.

Use a thick emulsion paint or acrylics. If you can't find the colour you need, remember you can mix your own; many DIY stores offer paint-mixing services, which will ideal when you need a large amount of a particular, custom-mixed colour.

Essentially, this is a fine-art still-life technique, and it works well with fruit. It works best if your choice of colour strongly contrasts the object's natural colour.

The reason an emulsion is useful is that you can paint a large area of paper to give you a matching background and you'll likely still have a pot left over. You can simply drop something like the orange illustrated here into the paint and then remove it using tongs or another tool.

Set up a table for your image capture with your background paper placed on top. Larger objects will probably require the paper to be curved up behind them. Light your subject from at least two places, using soft lights to minimize harsh shadows. We're not looking to draw the eye to the shadow here, but we do want to see some natural texture underneath the paint. An alternative is just to bounce a flash gun off a white ceiling.

If you're shooting fruit, as in the examples shown here, you might want to cut it in half. This is the tricky part. Use a very sharp chef's knife. Nothing else will cut it (sorry). Seriously though, you're aiming to make a perfect slice of a slightly squishy object without cracking the paint. This will be easier to do if the paint is nearly but not entirely dry — leave it overnight, and it'll be more likely to crack. To solve this, keep a little paint

to touch up any cracks. Have a piece of kitchen roll or other absorbent material handy to absorb any run-off from the paint as you cut.

Capture your still-life several times — after all, it has been a bit of a fuss to set up — checking for drips and wiping clean as needed between each capture. Be sure to get a good balance in your composition in terms of the reveal of the 'real' against the artificially coloured section.

Notes

This technique works best for fruit, but the only true limit is your imagination.

An eye-catching method, it goes against viewers' visual biases. We think we know what something is going to look like.

Opposite: Spray painting is an alternative to using thicker paints, and you can source metallics from a motor-supplies store.

Above: Orange and blue are opposite colours on the colour wheel, and the light reveals the texture of the real fruit in the painted exterior.

Right: This pineapple has been painted in pale blue, and then dipped at an angle in another colour after the first layer dried.

High-Speed Capture

Stop things in their tracks.

High-speed captures can be incredibly satisfying, and they can also be incredible fun! This example involves filling a balloon with water and capturing the moment of its bursting. Taking advantage of the limits of your camera's shutter can yield some interesting results that are sure to garner attention and, if nothing else, can be added to your microstock collection.

You will need either a great deal of patience and luck or a trigger that reacts to sound. Some have an array of sensors on board, but we are going to be using the sound-release feature. (See the 'Gear Tip', below right.) Before you start, you will need to take some precautions. Make sure your flash is covered with a clear plastic bag. If you like to keep your floor the way it is, then I'd suggest protecting it with a small pool too.

High-Speed Sync

You will want one or maybe two flashes that support high-speed sync to at least 1/8000 of a second. Some cameras will only let you go up to 1/4000 of a second. That's okay, there's a solution. This technique is similar to using rear-curtain sync. Rear-curtain sync is a useful technique that fires the flash just before the shutter closes so that the ambient scene is captured and then the action frozen in its final position.

In this case, we want to fire the flash while the shutter is open, in immediate response to the sound of the balloon popping. If the shutter speed is 1/4000, and the flash has a 1/8000 duration, then the effect will be similar to rear sync.

The best way to do this without getting technical is using a longer exposure in a darkened room. The room must be pitch black, and you need to cover any light or white surfaces in the room so they don't reflect the light from the flash. Some flashes allow you to control the power, sync speed and duration, however most flash units are quickest when the power setting is reduced. Some are as fast as 1/20,000 of a second. On your first try, use a low flash setting.

As I mentioned before, you will need a smart trigger such as a MIOPS or similar, on which you can adjust the sensitivity of its reaction. The trigger also must be hardwired to the camera, a remote won't cut it. Try this using very little or no water at first to save a huge clean-up job later.

You'll need a light stand with a boom arm, some string to attach the balloon to the boom arm and one or two flashes on stands pointing at the balloon. If you want to use a grid on your flash, then that's fine too, it helps to control light spill, which is certainly desirable. Cover up all your flash equipment with clear bags.

Your flash(es) should sit at the 4 o'clock (and 8 o'clock) position(s), with your camera at 6 o'clock. Attach the trigger(s) to your flash(es). Make sure they are exactly equidistant from the balloon and your camera, otherwise you might get the flash slightly off-sync. Place the camera on your sturdiest tripod and, using a torch (especially if your camera needs to get a phase-detection autofocus reading), focus on the balloon and then switch off autofocus. If you're using a camera with a focus-peaking feature, then just double-check the focus and fine-tune as needed.

Notes

Flash is needed.

Cover your flash and gear with protective bags.

A smart trigger needed, but you will find this useful for so many other things too!

Have plenty of spare balloons.

Gear Tip

The Pluto Trigger is a great choice if you've not already got a smart shutter because it's easy to operate; it connects to your smartphone via bluetooth so you can adjust the settings in an easy-to-navigate app, and to your camera via a cable for speed. The manufacturer's site will advise you as to which cable is best for your camera, as well as listing unsupported cameras so you don't waste your money.

This Page: The possibilities are endless. You'll get a different composition every time. It's possible to really go down a rabbit hole with a technique like this one.

Don't forget to set up a little pool underneath your drop spot, otherwise you will be getting your floor messy once you graduate to full water balloons. And, don't forget the most important part: a pin or pointy object that can slice a balloon open with ease!

Camera Settings

Set your camera to a 10–20 second shutter speed; this gives you time to pop the balloon without using Bulb mode, which can be difficult to get right. Your ISO should ideally be around the 100 to 800 mark – the lower the better.

You can test for exposure easily:, turn the lights off and clap your hands, everything should trigger. If not, then check your smart trigger sensitivity settings and try again. Repeat until you get it right.

So, lights (off), camera, action. When everything is set, start popping some waterless balloons and gradually add a small amount of water. If you find that everything is too dark, just boost your ISO to the next level up.

So now you should have some balloon-popping images. Some different ideas are to switch out the pin for a sharp pencil thrown at the balloon, or maybe to pop it over someone's head. Changing the water for paint is also fun to do.

Water Droplets

In much the same vein, capturing a water droplet as it hits the surface is something that can require a little time and patience. Again, you don't need a high-speed sync; it's perfectly possible to pull this off with a standard camera body. The examples here were caught with a camera-mounted flash limited to 1/250 of a second when shooting with flash.

The difficult part here is getting the focus on the point where you're dropping your water, but if you're dripping it from a fixed point and your camera is fixed, then the impact point should not change. So, with a

light turned on, place a sponge on the surface where the water will drip and focus on the sponge's texture. Manual focus is best here, and the electronic viewfinder to zoom in to show you the pixels.

Once your focus is set, remove the sponge a nd allow the water to settle before resuming work. Meanwhile, you can make any lighting tweaks you need. Shoot continuously as you drip the water from an eyedropper, or something similar, and pick the best shots from the selection. (Be sure to keep your flash(es) well charged!)

Below, All: Focusing on the drip point is easier if you float a sponge in the water in the spot where you intend the drop of water to land. Use that to focus, then remove it. Allow the water to settle and continue to shoot.

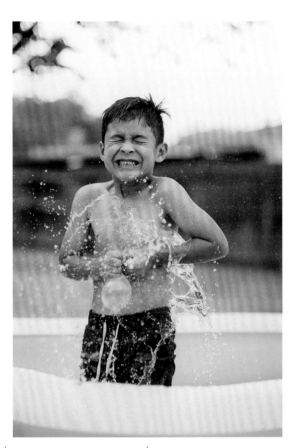

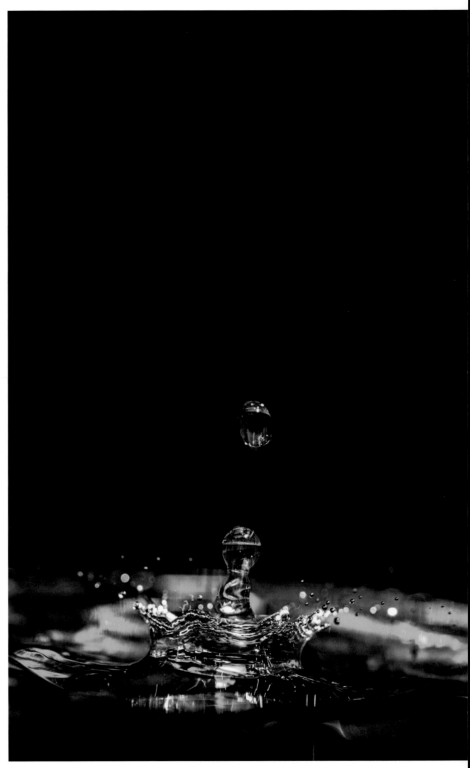

Above: Don't let tech get the better of you. You can still catch water in action with the tried-and-tested (if not technically perfect) method of simply holding down the shutter in Continuous drive mode. With a camera that can capture 10 frames a second in decent light, you might get a moment you like!

Right: It takes a little while to get it right, but when you do, it's so rewarding.

Motion Blurs

A bit of fun that we often forget, and great for stock!

In many situations you may wish to create motion where there is very little, or maybe the subject needs an injection of excitement. I use the following methods to create motion at weddings and events when the background or subjects are a little less than exciting. You can use these methods in action portraits too; it's a great way to create effects in-camera rather than in post-production.

In this section, we shall assume you are using slow shutter speeds, such as more than 1/80 of a second, shooting rear-sync flash and with a zoom lens attached. If you don't have a zoom, then you can skip the zoom method and jump straight to the twitch method.

Rear sync will set your flash off just before the shutter curtain goes down, thus freezing the action right at the last moment. This is how the blur will be created because we are going to exaggerate the motion before the flash and curtain finishes, which will blur everything before the flash goes off and then freezes it at the last moment.

Zoom Method

You can start at a wide angle and then push the zoom in closer to the subject as you release the shutter, but be mindful of keeping the subject in the centre of the frame. As you zoom, everything outside of the centre will be blurred in a forwards motion. You may need to use slow sync rather than rear sync for the zoom, but that depends on your shutter speed.

Twitch Method

You can use this method with a prime lens or a zoom, but you do need to keep to one focal length for the whole exposure. Hold the camera with both hands. Imagine holding a steering wheel: one hand will go up and the other will go down around the wheel as if you're swerving the car, but in a microscopic way. So, for example, go from holding the camera at 3 o'clock and 9 o'clock, you move to 2 o'clock and 8 o'clock.

This method is a little trickier, as you have to make sure your subject is on the same 'twitch point' on your lens. That might sound confusing, but what that means is the centre point of the frame must remain constant.

So if you get that wrong, you could be missing your subject and getting something else in focus, meaning your subject will be blurred out. This method does take some practice.

Above: The zoom method works well at night.

Left: You can always move the camera freehand to get some interesting blurs, though it's a bit hit and miss.

Opposite, Top & Bottom: This is the rotational blur effect you get using the twitch method.

Sell Your Gear

You might forget that most of your gear is pretty aspirational. Take its photo.

How much do you spend on equipment? A small fortune, I bet. (Or maybe a big fortune.) Do you have a powerful computer? Of course. Have you got a load of cool peripherals too? Seems likely. Don't forget that these essentials are all great props, and could probably make part of a great collection of stock images. This is especially true if you've just added the latest item, as plenty of people will be searching for images of that item in particular. Make that expensive gear earn its keep!

If you've got the space to set up some desirable gear in a pleasing arrangement, there is no reason why not to do so. There are a couple of different approaches you might take:

Clean Views

A little like food photography, capture the item cleanly and softly lit to show it off to best effect, perhaps as part of a still-life arrangement with other objects that make sense for a user of the item itself.

Workspaces

If you're shooting something like a laptop – indeed any potentially creative tool that doesn't look amazing on its own – have a simple image on the screen that shows relevant software. Place the machine as tidily as possible, then build up the environment you'd like to work in to create your scene (or the environment you imagine is appropriate). Coffee is always a good prop, but headphones and speakers might hint at podcasting or music creation, while a notebook might hint at a writing or editing. If you're creating stock, a fairly neutral scene with several versions including different props is the way to go. And don't forget to mention the props in your metadata.

Rules

Depending on your agency, you might find that they're not interested in carrying stock images with other companies' trademarks. Even something like an older

iPhone, identifiable simply by the icon in the home button, could be too much. That's certainly true of Adobe Stock – so before you invest too much time arranging gear, be sure you have a market for it. Retouching out logos might solve any such problems.

Among other potential buyers for these images, publishers reviewing products need pictures of them, and they might not have the time or resources to do so themselves. Markets outside the US are not so restrictive either.

Notes

Shoot as many configurations, scenes and combinations of products and props as you have time for. Something is bound to sell!

Don't expect to sell enough images to pay for the gear.

Above: A scene without props looks altogether different.

Left, Top & Bottom: Whatever it looks like, your workspace will mean something to someone.

Left: Scene-wise this shot is great. The gear is in a nice working environment, unlike a lot of the press materials that manufacturers supply, so it's useful. It also serves to illustrate the limited life of these images; this MacBook was replaced in late 2018 and the phone is several more generations behind.

Above: Sony and Apple are desirable brands, and this composition is clean, so this image could well appeal to a designer.

It's a Macro World After All

Light your macro images for more punch.

Every shooter should have a great macro lens. They are handy for portraits, wildlife and even sports, so the investment in a close-focusing lens isn't all spent on close-up shots.

Much of the small world is very easy to capture (those bits that stay still), but lighting can be a whole new ball game. Once you have your composition nailed down, how do you get backlighting or rim-lighting on a flower or insect, for example? Well it might be easier than you think. LED lights (small but powerful) are always handy, as is coloured cardboard. What, what? Yes, cardboard! Using card can serve a few purposes.

Even with lots of bokeh, a background can seem a little dull, so one great cheat is to place coloured cardboard behind the subject. Another background hack is to print a nice, neat image on a piece of white card that's been 'pre-bokehed', – doing so not only hides a messy real-life background, but it also means you have full control of how the miniature world will look.

White cards can also be used as reflectors in much in the same way you would use a full-size one to fill shadows in a portrait. (You can use this same technique with food photography as well.)

This front-light method may need an additional pair of hands. Grab yourself a small reflector, something smaller than 30cm (12in), and then cut a hole in the middle the same size as your lens. Stick the lens through the hole, and you have a scaled-down version of the Westcott ring reflector which is available to buy from camera shops. If you have a camera with no electronic viewfinder (EVF), you will need to shoot in manual focus and use live view, as you will solely be using the rear screen at this point. (The reflector will keep you from being able to see through the viewfinder.) If you do have an EVF, then you're in luck!

At this point, you can subtly backlight your image with LEDs shone through a pane of glass tilted towards the back of the subject. Or, perhaps you have another source of backlight – natural light, flash, a mix of the

two. The light will be bounced straight back at your subject, giving it a studio feel, wherever you are.

Focusing in Macro

Each macro lens worth its salt will have a focus limiter on the side, next to the MF/AF switch. The distance for focusing is listed on the side and you should use it to narrow the range the AF needs to hunt through so 0–infinity is going to be more irritating than 0.3–0.6, for example, and 0.6–infinity, no good for close-ups at all.

So, my advice for macro focusing? Switch the focusing to manual. If you really want to use autofocus, use the limiter to keep things manageable, but then switch to manual focus to fine-tune.

Notes

LED lights and cardboard are two basic and inexpensive items which can really up your macro game.

Remember to check for macro switches on lenses (and that you haven't accidentally disabled the macro range).

Left: The shot, using an on-camera reflector

Below: The shot, without an on-camera reflector

Above: Macro photography is something you can do in your own garden, and it can give insights into another world. Nature provides a bountiful supply of interest when we look a little harder than usual.

Right: Not every macro shot needs to be of the traditional subjects (tiny insects and flowers). Man-made subjects with interesting details are also well worth capturing from a commercial perspective, and as stock. With something like rope, keywords should include fishing and boating.

When you start shooting take plenty of different shots with slightly different focal planes, as you may want to do some focus stacking in post-production. Even if you are intentionally going for a very shallow depth of field, you might decide on a different composition later down the road. Basically, shoot lots.

Focus Peaking & Zebras

The huge advantage with EVFs and live-view modes is that you can see plenty of information that's useful for helping you get the style, exposure and composition you want.

There are a few settings you will need to enable to get all this to work: enable focus peaking, and set the colour value to the opposite of your subject (or close to it). So, if you are shooting a yellow flower, make the peak colour red, for example. I would avoid white, as its normally difficult to see.

Also turn on your 'zebra warning' that tells you when areas are overexposed. The histogram can be a useful tool, but it is always great to get the vivid warning of the zebra stripes, which will let you know exactly where in the frame overexposure is occurring. After all, you might actually want part of your overall composition to be overexposed in some way.

Light Pipe

Let's get creative! There some brilliant ways to make your macro images look super-special. Using some ordinary household objects (and some perhaps less ordinary ones), the options are limitless.

Plumbers' piping is good fun to use and you can find it in every hardware store. You will only need around 2.5–5cm (1–2in) of 2.5cm or larger pipe. Copper, silver and white plastic all work well, and if you wanted to drill very small holes into the side of the pipe to make light leaks, then try it out. It's a bit of a knack to get it right, but it's always worth a try.

Holding the pipe between the lens and the subject

and shooting through it creates a lovely swirl effect. Changing one pipe material for another will give you variations over the course of the shoot.

Optical prisms (always handy to have in any case) are great for achieving retro-style splash-of-colour and light-leak effects. Prisms come in many shapes and sizes. My personal favourite is the classic triangle, but the crystal ball (see page 24) is also handy, as it keeps the bend of the light through the frame, which is very pleasing to the eye.

Water spray

Introducing water onto your subject can be a nice way of adding interest. This trick works well with flowers and plants, but the options are limitless. (Ionized water works best.)

Notes

A water spray is a handy tool for a more captivating shot (and saves getting up early to capture the dew).

Plumbers' piping can direct light usefully.

Take captures at various different focus planes.

Left: If you find a macro image dull or lacking something, spritzing some water onto the subject might liven things up a bit.

Top, Right & Left: Take a number of captures of different focus points so you have plenty to work with.

Above: A flower photographed without a light pipe.

Left: The same flower shot with a light pipe.

6

**Business
Building**

Keep Current

Use your downtime to explore new possibilities and stay ahead.

Although photography is a creative industry, we are all inclined to a certain conservatism about the way we work. At times it feels, and is, essential; something that worked one day should work the next. That's why so many photographers let fly with volleys of anger whenever something they use is updated.

Anyone that doesn't pay attention to technical change, however, is at risk of being left behind. As a professional, it's easy to miss improved ways of working because you stick to a tried-and-tested workflow. For most photographers, that includes a program like Lightroom or Capture One that allows you to quickly import, store and review a large number of Raw files, but there was a time when those tools didn't exist. When they were first introduced, there was a spell where these tools were viewed with a great deal of scepticism by many photographers.

What Seems Like Hard Work?

If it's easy to identify something in your workflow that is slowing you down or isn't working, or if there is something repetitive in your process, then that might be something that has been addressed by a software developer, for example. Talk to other photographers and find out how they're handling the same problem. They might have it figured out. There is no sense in reinventing the wheel.

Failing that, your problem might actually be something you can address using Photoshop Actions. In the 'Flambient' section (page 96), we looked at the need to create two layers, one with a mask set to Luminosity. Creating a Luminosity mask follows the same process each time, so you can simply start with an image in the same state (with the two layers) then open the Actions panel and press Record at the bottom.

If your action involved opening or saving, you can also perform the action as part of the Batch feature and tell the batch function to open selected files rather than the file you opened when you created the action. That

way, you can create an action that, for example, opens a file, converts it to black-and-white, then saves it. Afterwards, you can go to File > Automate > Batch and use the action on a number of images, being sure to choose 'Override Action Open Commands' in the panel.

Though they didn't exist a couple of decades ago, actions can save you hours and hours of work. Now apply the same concept to changes in the market. There's always some new technology that can revolutionize your workflow. Keep an eye on the latest developments in the biz!

Below: The Photography Show, Birmingham, and PDN PhotoPlus, New York. Survivor's tip: arrive ten minutes after the gates open – there is no good reason to be in the crowd at the gate!

Far Left: The Photoshop Actions panel features familiar Stop, Record and Play icons, making it easy to record a process you do time after time.

Left, Top: When you press Record, you get the option to assign a keyboard shortcut.

Left, Bottom: You can see your new action in the Actions panel, next to its keyboard shortcut, and if you click to open it, you can see the individual steps you recorded.

Attend Trade Shows

A great way to stay up to date is by attending photography trade shows, which in the last few years have shifted in their focus from retail towards the exchange of information between photographers. That's why events like WPPI (Wedding & Portrait Photography International) have grown.

Sure, they're still a jamboree of media but they're also filled with presentations from leading photographers, many for free. Since the free ones are typically sponsored by software and hardware developers, you can sit, watch and see if they're talking about something fruitless from your perspective (the addition of a few megapixels, for example) or something which could change the way you shoot or process your images. All of this comes at very little cost and gives you the chance to stay current.

Left: As with many modern camera bodies, the Sony a7 III can be remotely controlled using your phone (including remote viewing through the EVF on the phone screen) and can download images wirelessly to your phone or your computer. This kind of system can keep you ahead in the world of weddings, where you can instantly share your images on Instagram with the guests during the event!

Online Promotion

Incredibly few pros take advantage of simple and cheap search advertising. Stand out.

For many creatives, the idea of actively promoting their work is an affront to the higher calling of their artistic side. If you think like that, then well done, but you're not a professional. A professional needs to attract clients, and even one who has enough customers to keep them busy would surely benefit from more to choose from.

Others have the wholly and sadly misguided idea that social media is a benign force which will work in their favour if they post good images which earn likes. This might be true on a small scale – 'better' pictures certainly pick up a few more likes – but manipulation is often the only way to reach the kind of numbers that look truly successful. Instagrammers often fall prey to services which are designed to boost their account's following. These services operate by automatically controlling an account for a fee. Automatic 'bots' follow tons of other accounts and, when they detect that someone has politely followed them back (as you or I might), they discretely unfollow.

This kind of thing is going on all the time, but there is a more honest way to go about things which is so ingrained into the way we use the web we almost forget it. Google isn't the vast force it is from the money it makes selling phones or smart doorbells, but from its Google Ads advertising system which allows you to create sponsored links that direct traffic to your site.

Google Ads works by directing people to your site when keywords that you choose are searched for by the Google user. You only pay when someone clicks on the link, and you'll need your site to do the job of keeping them there.

If this sounds a little random, worry not. You most commonly advertise by setting a budget that caps your daily spending. How many visits this will buy you isn't entirely clear, however, since Google calculate the value based on their own formula. It might decide, for example, that a certain keyword has a very high value, which means that each click on your link might be charged at $1.00, whereas a different formula of

keywords might only be worth $0.25, meaning that your budget will get you four times as many clicks.

So your spending is under control, but what you get for it isn't exactly clear. Nobody said life would be easy. In truth, though, given the peculiarities of the mechanism, Google have gone a long way to make it easy to use.

Create an Ad
Be as specific as you can, because you only get so many characters for a headline, subhead, and sentence to encourage people to visit your site. Don't use fluff though; this isn't the time for click-bait ('Nine Things You Didn't Know a Photographer Can Do to Fix Your Teeth'), as you only want clicks from potential clients likely to spend money.

Choose Keywords
It is best to be as specific as possible. You don't want to be paying for clicks for subjects as broad as 'photography'. You can create as many keywords as you like in a string, so, for example, it will cost you when someone finds you via the keywords 'Queens real estate photography', but this is much more likely to pay off, when it brings only genuine potential clients.

Geo Targeting
Make sure you also use Google's location targeting systems to filter out clicks coming from anywhere you can't realistically do business. You can narrow it down to a city, state or a number of countries – it's entirely up to you.

Notes

Create a Google AdWords account.

Use free advertising like Google Maps.

Set aside time to evaluate your success using the tools available.

Above: Google Ads allows you to run a number of campaigns and makes it easy to keep track of them.

Left: Google Maps is another great service which can provide free advertising if you draw attention to your studio or office location. If people are searching for local photographers, they'll be directed to you.

Where the People Go

Keep an eye on local listings; many events will give photographers great access.

You might think that the wave of DSLRs brandished by enthusiasts means that holding one doesn't make you stand out from the crowd, and there is an element of truth there. It's not as easy as it used to be to get by simply by looking like a professional. So instead, you need to be one.

In other words, when you see something coming in listings that will yield great pictures, there is no harm at all in contacting the organizers and asking if there are passes for photographers. Many of the greatest music photographers started out by simply trying to get free access to a gig this way and taking full advantage of the access offered.

In a way, Instagram is your ally here; there will be so many poor pictures of an indoor event – where even more modern phones struggle to capture a good image, with their tiny optical components – that your photographs are bound to stand out. To make good commercial use of this, post as quickly as possible, and use the relevant hashtags. It's a bit hit and miss, but you're effectively advertising yourself to any attendee who looks at the event on Instagram, and many might be tempted to follow.

Other great opportunities to use this approach to marketing are fireworks displays or astronomical events like an eclipse; if you plan ahead and use a tripod (or the appropriate filters), you're bound to get decent pictures, where those who just raised their phones to the sky in the moment do not. As they page through the event, your images will stand out, allowing you to build connections with local people – potential future clients.

I'm not saying, by the way, that this approach will add tens of thousands of new clients straight away. I think of it more as something to keep in the back of my mind when I'm planning to go somewhere anyway. Keep it stress-free by just carrying the gear you're most likely to need, and you can still enjoy the day.

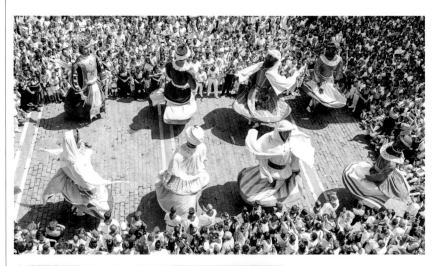

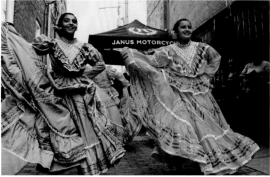

This Page: Keep an eye out for local events where you can fill your camera with interesting views. By arranging access with the organizers beforehand, you will often also be able to get far better views than those available to the masses.

This Page: Various images captured with the advantage of a photographer's pass to events.

Test Yourself,
Test Your Gear

Grab a camera and a single lens and head out somewhere ugly.

Experienced photographers, especially professionals, come to rely on several bags full of very helpful, very powerful equipment. Depending on your niche, you'll often be shooting subjects which are fairly photogenic in the first place, or at the very least you'll have the advantage of planning, so you'll be able to make sure they look their absolute best. You won't always be so lucky, though, so why not use any downtime to test your skills in uninspiring weather, with less-than-ideal subjects? One day you'll appreciate it.

Self-criticism is the key here; many photographers at different levels pay a great deal of money and travel great distances for personal meetings with commissioning editors or experienced photographers to have their work appraised. If you can be honest with yourself, though, you can avoid those costs. A quick aside: those organized portfolio reviews can be of great value and – if you're lucky and are matched with someone in the position to give you work – can lead to a good and prosperous client relationship.

The other benefit is that you'll be able to test your gear not necessarily 'to its limits', but certainly 'in use'. In use, but, crucially, not in the service of clients or any other kinds of pressures, so you can feel comfortable playing around with the settings. This is a great opportunity for you to familiarize yourself with the nuances of your autofocus system, for example.

They say a good photographer is not about their gear, and that's true. Gear doesn't make a photographer, but a good working relationship with the gear is vital. It makes you more comfortable with it and quicker when you need to be – like building muscle memory.

Notes

A successful shot of an unappealing subject is a goal to keep setting for yourself.

Restricting yourself to one lens will give you a chance to really experience it.

Left, Top & Middle: Here, a single lens and an innocuous garden wall provide an opportunity to fiddle with the focus.

Left, Bottom: Finding the symmetry in an unappealing spot. However, it would have been a lot better to wait for a solitary figure to appear nearer the camera.

Above: Self-criticism: The cup seemed an interesting feature on a grave stone, and the wide aperture makes the background blend, but the angle is dull.

Above: Self-criticism: The ivy marked this out from the other stones, but the tree in the background is a bit distracting.

Above: One of the better views of the graveyard while restricted to a 50mm focal length.

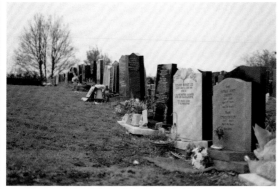

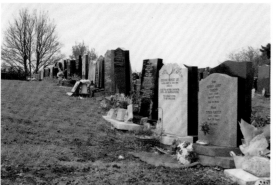

Right, All: It's interesting to see how dramatically the exposure control and white balance were affected by changing the viewing angle.

Left, All: The bottom image is slightly better than the above. A low angle and a diagonal line for the eye to follow.

Moving Pictures

Chances are you have a high-end video camera. Do you use it?

Nearly every still camera is capable of capturing, at the very least, high-definition (1080p) video, and more recent models are usually capable of shooting in 4K. Capturing a promotional video is a great way to connect with potential clients, especially in areas where you're likely to be working regularly, and editing a short promo isn't too tricky. Why not reach out?

Traditional photographers' websites tend to be a bit static, showing a series of stills which form a portfolio. This is great, but typically, the sites are a little slow, and although it's not difficult to share the link to it, you can't be sure people will explore it to the extent you'd like. If you can create a short video, you can upload it to a platform such as YouTube or Facebook, and from there embed the video into other platforms, and your potential customers will be able share it themselves via the share within the apps.

The trick is to try to not to be overcomplicated or long-winded. What you should aim to do, ideally in no more than 30–40 seconds, is introduce yourself (an actual shot of you talking to the viewers) and the highlights of your portfolio, making sure you close with all the necessary links to your work on the screen. People who see the video and like it will explore your portfolio online.

Time is of the essence in video, and that's something it's difficult to get used to for still photographers. In fact, it's not that easy for traditional film directors to appreciate quite how much you need to do in a short period of time, since the increase of video content in the internet age means people are inclined to click away quickly. Remember, too, that plenty of people either pay for data or used to, so the audience has built up an instinct to abandon a video very quickly rather than incur data charges, and that's not an instinct that entirely goes away even as people switch to less onerous tariffs.

The tried-and-tested solution to keeping the viewers that you want is to speak directly to them right at the start. I say the viewers that you want, because it's easy to confuse this with a high number of views. Views are nice, but what really matters is that those watching are also potential clients, and when you're embedding just the clip into another platform, the number of views won't be shown as obviously as when the page is viewed directly in YouTube, for example.

In the field of photography, it doesn't hurt to show the gear either (assuming it looks suitably professional). See if you can set up a second camera to show yourself speaking. Editing software can synchronize the video automatically, so if you have a few angles, you can swap between them just like in a live TV studio. A shot from behind you showing a camera on a tripod and a light need only be on-screen for a quarter of a second to make it clear you've got the gear to produce the film they're viewing, and it looks confident too.

Don't try to be too clever with your introduction. Start with something like, 'Hi, My name is Dan M. Lee and I'm a real estate photographer working in New York.' (Note the use of my full name and location.) You could continue: 'I use the latest gear...' Keep talking to the camera, but the chances are you'll edit in half a second of a shot of a camera and lenses or something. '...to capture stunning photos of apartments and houses...' Again, you'll be able to edit in some final examples. '...and the best software to make any room look great.' Here, you can quickly show a sequence of images leading up to the final one. You could even throw in a quarter-second of screen-capture showing a brush in Photoshop. The point you're aiming to get across is the value you bring in processing – a skill the mobile-phone brigade can't lay claim to!

Notes

Create a short video that you can embed in other pages.

Don't be overly clever, but do try to show the skills you have that others do not; show your value.

Introduce yourself and your function before showing still images on screen.

Use the 'Ken Burns' effect (panning and zooming), but only sparingly.

Opposite, Bottom: A little bit of whimsy here – the video shows me drawing a camera with a pen – a bit of light-painting – and the camera remains. This was done using Pixel Booth that I rent out at events. If you explore my YouTube videos, you'll find it.

Above: A combined clip in Final Cut Pro. Only one audio source (the room microphone) is used in the edited video – the others are muted – but the sound is used for the system to automatically synchronize the video so you can just watch and tap between the camera angles, like Timothy Busfield in *Studio 60 on the Sunset Strip*. The camera angles are shown in the middle, but only one bar appears in the edit ribbon. This is me appearing on *The Photographer Podcast*.

Top: This is a video as seen in Final Cut Pro, which shows how a modern video-editing tool works. A 'ribbon' is created (the main line with thumbnails and purple bits, aka titles). You can drag and drop photos in, or remove them. Additionally, you can overlay (like the clip at the top), or add video. You might well find that iMovie is more than adequate though.

The Cinemagraph

Part photo, part video, a social-media favourite that will gain you likes.

Establishing a presence in social media is an uphill task, and as we've already mentioned, you'll want to use some kind of advertising to grow your numbers, but it does still help to have striking content. The proof of that has been seen before.

In the past, Boomerang, the feature on Instagram which allows you to make short video clips that play backwards and forwards repeatedly, was not a mere part of Instagram; it was an app on its own. So popular were the ever-playing clips (featuring potentially hilarious splat/unsplat/splat scenarios, etc.) that the feature was incorporated into the main app and we must now look a little further for stand-out video tricks. One source of these is pre-programmed 'Quickshots' from the drone world, but those are definitely ones which also incorporate fast movement and processed effects.

The 'cinemagraph' is rooted more firmly in still photography. It works by analyzing a photograph and making some elements of the image move while others do not, so, for example, a foreground subject like a cityscape or a model would remain fixed, just as they were shot, while the clouds in the sky or the surface of water in the background were set to move. The motion of the latter is easily simulated in software, so the process can be performed on a still image rather than taken from a video clip as you might imagine.

As of now, this effect is not built in to Instagram, and doesn't have quite the level of dominance that Boomerang managed before its acquisition; but it has rather more rarity value, which is a good thing. Of course, that's true because it's somewhat harder to get it right, but no work, no value, right?

Masking

There are a few cinemagraph apps available, many for free (the one I've used is Plotaverse). Once you've installed an app, you'll need to open your image and then begin with the masking tool to cover every area of the image you want to remain perfectly static. Hills,

models, etc. should be in this category. You will be able to refine the size of the mask with an eraser, or simply by shrinking the size of the brush. A magnifying tool automatically appears.

Anchors

Anchor points set areas in the image which absolutely cannot move. These are useful along edges, especially if you're going to have a horizon with a sky moving one way and the sea moving another. If this is the case then a row of anchor points is the solution.

Animation Lines

Draw these where you want to see a magic unending animated flow. The actual clip will be about 6 seconds, but will cycle in the directions you pull. As you can see, I've added a number of arrows.

Uploading

Once you have finished, then you can choose to upload to a selection of major social media platforms. Depending on your app, this may come at the expense of watching an ad or a subscription fee.

Notes

Cinemagraphs can be created on your phone.

For stand-out images, start with photos from your camera and copy them to your phone.

Various apps are available – the one I used is called Plotaverse.

All: Here you can see the steps of masking, adding anchors, adding animation lines, making final edits, and then exporting to Instagram. The result, sadly, cannot be reproduced on paper!

Endmatter

Index

3D Vista 102

acrylic paints 142
Actions panel 158–9
Adobe Stock 62, 150
advertising 160–2, 168
AEB (Auto Exposure
 Bracketing) 26
AEL (Auto Exposure
 Lock) 14
aerial photography 38,
 110–13, 116, 118, 124
AF (Auto Focus) 48, 60,
 64, 144, 152, 164
afocal method 34
air 108–35
aircraft 110, 112–13,
 116, 118, 120
ambient light 54, 56,
 66, 68, 96, 128, 138,
 140–1
amenities 90
anchor points 168–9
angles of incidence/
 reflection 20, 134
animation lines 168–9
AP (Aperture Priority) 10,
 26, 28, 48
apps 18, 20, 30, 32, 62,
 86, 94, 138, 144, 166,
 168
APS-C cameras 126
artificial light 56, 68, 130,
 138, 140
assistants 64
Auto Align Layers 96
AWB (Auto White
 Balance) 14, 36, 82,
 96, 112

backlighting 152
backscatter 1 30
balloons 144–6
batch function 158
black and white 42, 56, 78
Bluetooth 144
blur 10, 24, 48, 83, 86,
 118, 128, 148–9
BMP files 70
bokeh 60, 72–3, 76–7,
 128, 138, 152
Boomerang 168
bots 160
Bulb mode 32, 68, 146
Busfield, Timothy 167
business cards 162
business skills 156–69

cable release 30, 36
camera types 10, 26,
 34, 48, 60, 102, 105,
 116–18, 124, 126,
 144, 158–9, 166
Canon 34, 116
Capture One 10, 26, 34,
 82, 158
cardboard 152
catchlights 52, 60
chromakeying 82
Cinematographs 168
cities 8–45
cityscapes 110, 168
click-bait 142, 160
clients 6, 18, 42, 54, 58,
 62, 64, 70–1, 84, 90,
 92, 96, 140, 160, 162,
 164, 166
Clone Stamp 94
clothing 68, 112

clouds 16, 30, 37, 114,
 168
colour wheel 143
Colourize 78, 84
compact cameras 126
composite images 82, 97
composition 10–11, 16,
 34, 40, 42, 51, 56, 60,
 79, 118, 124, 128,
 130, 134, 142, 145,
 151–2, 154
concepts 136–55
converging verticals 44,
 72, 114
copyright 62, 120
CPLs (circular polarizing
 filters) 10–11, 14,
 16–17, 45, 94
crystal balls 24–5, 154

D-Range Optimization 14
daylight flash 56
depth of field 10, 26,
 38, 48, 60, 82–3, 124,
 132, 154
detail 15–16, 22–3, 26,
 29, 42–3, 50, 60, 62,
 72, 76, 90, 92, 96, 99,
 112, 116, 121, 128,
 142, 153
diffusers 130, 138
diving 126–8
DJI Mavic 118, 120,
 122–3
dolly tracking 124–5
drones 114, 118–22,
 124, 168
DSLRs 30, 102, 118,
 126, 162

dual operator mode 120
dynamic range 14,
 26–8, 36, 82, 90, 92,
 96–100, 104–6, 112,
 121, 124, 166

Elinchom 66
emulsion paints 142
Enfuse 26
equipment photography
 150–1
events 64, 148, 162–3,
 166
EVFs (electronic
 viewfinders) 146, 152,
 154, 159
eXifer 106
ExpoDisc 14, 56–7
Eye Focus 60
eyes 52, 110

facades 92
Facebook 102, 106,
 122, 166
fauna 128
filter system holders 14
filter types 10, 120, 138,
 162
Final Cut Pro 82, 167
fine-art techniques 142
fish 128
fish tanks 132
fisheye lenses 32, 102,
 126
flambient images 96, 98,
 100, 158
flash 32, 36, 54, 56,
 66, 68, 70, 80–2, 94,
 96–101, 128, 130–1,

138, 142, 144, 146, 148, 152, 166
flora 128
FlyNYON 116
focal length 30–1, 60, 83, 124, 148
focus peaking 34, 60, 144, 154
focus stacking 60, 154
food photography 138–42, 150, 152
free passes 162–3
front lighting 152
fruit 142–3
furnishings 90–1

gels 66–7, 140
geo targeting 160
gimbals 118
glare 10, 16, 101
gliders 110
goggles 110
Google AdWords 160–1
Google Earth 110
Google Maps 20, 160–1
GoPro 102, 124
graduated filters 14–16
grain 112
graphic designers 78
green screens 82
grids 66, 80–1

hacks 106, 130, 152
hang gliders 110
haze 110, 114, 117
HDR (High Dynamic Range) 14, 26–8, 36, 82, 90, 92, 96–100, 104–6, 121, 124, 166
Healing Brush 94

helicopters 110, 112, 116
high altitude images 114
high-speed sync 54, 144, 146
histogram 26, 105, 154
housings 126–7, 130, 132
Hue/Saturation 78, 84

image quality 28, 116
image ratios 106
Image Stabilization 10, 48, 112, 116, 118
image stacking 32, 36
iMovie 167
InDesign 62
Instagram 159–60, 162, 168
insurance 120
interiors 88–107
ionized water 154
iPads 94
iPhones 42, 116, 150
ISO settings 10, 26, 28, 30, 32, 36, 48, 54, 66, 68, 76, 82, 112, 128, 146

jars 132
JPEG files 26, 106, 123

kaleidoscopes 86–7
Ken Burns Effect 166
key lights 54, 82
keyboard shortcuts 159
keystones 38, 74, 92
keywords 153, 160

landscapes 8–45, 48, 124

LEDs 52, 66, 69–71, 96, 152
Lee systems 10, 14
lens whacking 48
lenses 24, 28, 30, 34, 42, 44, 92, 102, 110, 118, 126, 152, 164, 166
lifestyles 136–55
light drop-off 54, 66
light meters 36, 56, 82
light painting 68–71, 74, 166
light pollution maps 30, 32
light spill 54, 66, 80, 144
lighting 46–87, 96, 128, 130–1, 138, 140, 152
lightning 36
Lightroom 10, 26, 94, 96, 158
lips 84–5
listings 162
live-view mode 68, 126, 154
logos 71, 150
Long Exposure Noise Reduction 10
low light 20, 48, 117
Luminosity 96, 158–9

macro 38, 60–1, 126, 152–3
MagMod 54, 80–1
masking 98, 168–9
Metabones 34
metadata 62, 84, 106, 150
microlites 110
microstock 62, 144

MIOPS remote trigger 30, 36, 144
mirrorless cameras 30, 64, 102, 105, 126, 158
mirrors 94–5
monochrome 42, 52, 57
motion blurs 148
MUAs (makeup artists) 60, 84
Multiply blend mode 78

narratives 90–1, 93
ND (neutral density) filters 10–11, 16, 23, 36, 120–1
night images 30, 68, 112, 118
nodal points 102, 104

octoboxes 54
online promotion 160–9
orbiting 124–5
overexposure 10, 60, 82, 154

PADI Underwater Photographer course 126
Panos (panoramas)/360° images 40, 102–6, 122–3
parallax 102, 104–5, 125
Parrot Anafi 118, 121, 124
Patch 94
people 46–87
personal projects 58–9
perspective 6, 44–5, 92, 98, 114, 119, 124, 132
Phantom 121

Photographer's Ephemeris 20
Photomatix 26
Photomerge 40
Photoshop 26, 40, 54, 62, 70, 78, 82, 92, 94, 96, 98, 100, 134–5, 158–9, 166
photospheres 24
pilots 110, 112, 118, 120, 124
piping 154–5
Pixel Booth 166
pixel-shift mode 112
Pixelstick 70–1
planes 110, 113
Plotoverse 168
Pluto Trigger 144
podcasting 150, 167
Polygonal Selection 94, 98
portfolios 22, 58, 96, 110, 126, 164, 166
portraits 48–9, 52, 54, 60–1, 66, 78, 128, 148, 152
post-production 14, 22–3, 26, 28, 32, 36, 40, 54, 60, 67, 70, 82, 84, 92, 94–5, 102, 105, 112, 117, 124, 130, 148, 154
pre-programming 112, 168
prime lenses 26, 48, 76, 92, 110, 115, 148
prisms 154
projectors 74–5
promotion 160–9
props 138, 140, 150

Index

Quickshots 168

Raw files 14, 26, 36, 78, 112, 158
real estate 88–107, 160, 166
rear-curtain sync 144, 148
reflectors 56, 66, 82, 138, 152
regulations 120
releases 62–3, 86
Rembrandt technique 54–5, 66
remote controls 30, 32, 120, 144, 159
resolution 74, 116, 118, 122, 124
restaurants 138, 140
rim lights 82, 152
500 Rule 30–1
Rule of Thirds 18, 43, 92, 128
rules of thumb 110, 112, 138, 150

sea 108–35
settings 14, 26, 36, 49, 56, 70, 82, 98, 112, 127, 130, 144, 146, 154, 161, 164
showreels 124
shutter speed 10–11, 22, 26, 28, 30, 32, 54, 66, 74, 82, 112, 117, 128, 130, 144, 146, 148
side lighting 50–1, 53
side-on images 138–9
silhouettes 20, 22–3

skies 8–45
Slik 102
smart bulbs 96
smart triggers 144, 146
smartphones 18, 116, 132, 144, 162, 166, 168
social media 58, 64, 102, 160, 168
softboxes 50, 52, 54, 66, 82, 140
software 26, 28, 32–4, 40, 62, 70, 82–3, 102, 105–6, 114, 118, 120, 124, 150, 158–9, 166, 168
Sony 26, 60, 64, 102, 116, 151, 159
speedlights 54, 80
Spot Metering 14, 26
star trails 30, 32–4
StarStax 32
still-life images 142, 150
stitching 40, 102, 105–6, 122–3
stock photography 22, 44, 62–3, 72, 148, 150
street photography 42–5
strobes 54, 60, 66, 80, 82
subtractive colours 142
sunbursts 14, 28–9, 92
sunrise/sunset 14, 18–20, 117

T-Ring/T-Mount 34–5
Tamron 92
telephoto lenses 42
telescopes 34

texture 20, 94, 138, 142–3, 146
tilt-shift lenses 38
top-down images 138–9
torches 30–2, 68, 128, 144
trade shows 158–9
tripods 10, 14, 26, 28, 30, 32, 34, 36, 40, 48–9, 68, 72, 94, 96, 102, 104–5, 122, 144, 162, 166
TTL mode 130
TV screens 98–9
twitch method 148–9

underwater images 126–8, 130–5
UV (ultraviolet) filters 11, 16

video 74–5, 83, 116, 118, 120, 124, 166–8
vortographs 86–7

wall of light method 130
water droplets 146
waterfalls 10
WB (White Balance) 14, 36, 49, 56, 82, 96, 112, 140, 165
weather 110
weddings 64, 148, 159
wide-angle lenses 12, 26, 32, 38, 92, 102
windows 98–9, 112, 138, 140
workflow 158
workspaces 150–1

Yellow Pages 110
YouTube 52, 120, 166–7

zebras 60, 154
zoom lenses 48, 76, 110, 118, 148

Picture Credits

An Hachette UK Company
www.hachette.co.uk

First published in the UK in 2019 by Ilex, an imprint of
Octopus Publishing Group Ltd
Carmelite House
50 Victoria Embankment
London EC4Y 0DZ
www.octopusbooks.co.uk
www.octopusbooksusa.com

Distributed in the US by Hachette Book Group
1290 Avenue of the Americas, 4th & 5th Floors, New York, NY 10104

Distributed in Canada by Canadian Manda Group
664 Annette Street, Toronto, Ontario, Canada M6S 2C8

Design, layout and text copyright
© Octopus Publishing Group 2019
Illustration copyright © Dan M. Lee 2019
Additional images © their respective copyright holders

Publisher: Alison Starling
Commissioner: Frank Gallaugher
Consultant Publisher: Adam Juniper
Managing Editor: Rachel Silverlight
Development Editor: Rebecca Shipkosky
Art Director: Ben Gardiner
Designer: Untitled
Picture Research: Giulia Hetherington
Senior Production Manager: Peter Hunt

ISBN 978-1-78157-592-5

A CIP catalogue record for this book is available from the
British Library.

Printed and bound in China

10 9 8 7 6 5 4 3 2 1

ilex